WATERLOO STATION
THROUGH TIME
John Christopher

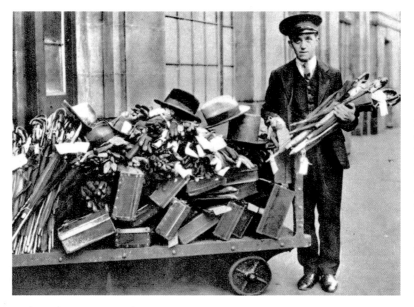

Left: Lost property from all over the Southern Region was collected at Waterloo at the rate of 110,000 items per year. The catalogue of mislaid items ranged from jewellery, briefcases, books and clothing to innumerable umbrellas and even the occasional pram. These remained at the office for up to three months, when all unclaimed items were sold at public auction.

About this book

The illustrations in this book encourage the reader to explore many aspects of Waterloo Station. They seek to document not only its history, its architecture and the changes that have occurred over the years, but also record the day-to-day life of this important railway terminus. Hopefully they will encourage you to delve a little deeper when exploring the station and its environs, but please note that public access and photography is sometimes restricted for reasons of safety and security.

First published 2013

Amberley Publishing
The Hill, Stroud
Gloucestershire, GL5 4EP

www.amberley-books.com

Copyright © John Christopher, 2013

The right of John Christopher to be identified as the Author of this work has been asserted in accordance with the Copyrights, Designs and Patents Act 1988.

ISBN 978 1 4456 1022 1

British Library Cataloguing in Publication Data.
A catalogue record for this book is available from the British Library.

Typeset in 9.5pt on 12pt Celeste.
Typesetting by Amberley Publishing.
Printed in the UK.

Waterloo Station

Lambasted by the French during its stint as the Eurostar terminus for celebrating the most famous battle of the Napoleonic Wars – in fact the station took its name from the road on which it stands – and immortalised in song by the Kinks and Abba, in the latter case singing about the battle this time, Waterloo is the busiest railway station in Great Britain, and in European terms it is second only to the Gare du Nord in Paris. Around 88 million people use Waterloo every year, not including those who travel on the underground or via neighbouring Waterloo East station. It's also the biggest. When all twenty-one platforms are in use – the two which served the Eurostar trains from November 1994 until 2007 are currently mothballed – Waterloo has more platforms and a greater floor area than any other in this country.

It is, therefore, all the more remarkable to learn that Waterloo was never intended to be a terminus at all. When the London & Southampton Railway line was opened as far as Woking in May 1838, its London terminus was at Nine Elms Lane, located to the south of Vauxhall Bridge on the Lambeth marshes. Like much of the area south of the Thames, this had yet to be covered by the outward spread of London, which was mostly confined to the north of the river. With no direct rail link into the city itself the railway company, newly renamed the London & South Western Railway (LSWR), provided a steamboat service to and from the City with intermediate pick-up points along the way. In practical terms, Nine Elms was no further from the centre of London than, say, Paddington, but the inconvenience of the river crossing made it seem more remote. In 1845, the LSWR obtained

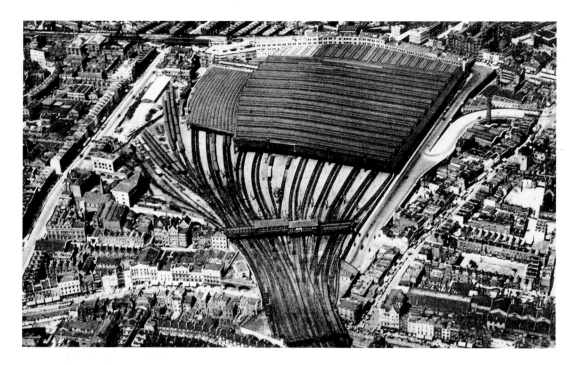

Waterloo from above. Platform 1 is to the far right, next to the Approach Road. In the 1930s photo the remaining roof of the North Station is visible, set back on the left, along with the sidings running up towards York Road. This is where the hoist for the Waterloo & City line was located. The site is now occupied by the snaking roof of the Eurostar terminal. (*Network Rail*)

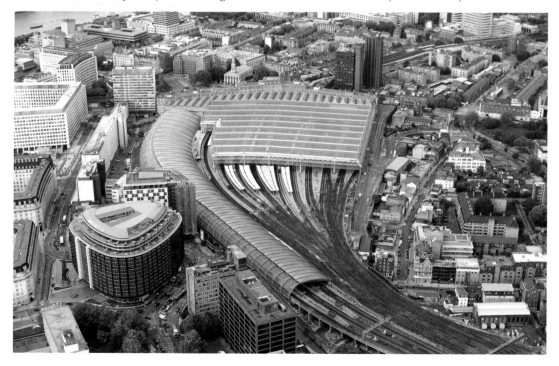

powers to build an extension branching off from the line just to the south-west of Nine Elms and leading to a new station in York Road, near the southern end of Waterloo Bridge (the original bridge designed by John Rennie had opened in 1817 but, because of subsidence, it was replaced by Sir Giles Gilbert Scott's concrete structure in 1945). When it opened for business in 1848, the Waterloo Bridge Station was only intended to be another station on an extended line going to a point near London Bridge or, possibly, crossing the river to terminate at Charing Cross. This explains why Waterloo has no goods yard of its own, as the LSWR continued to use the existing facilities at Nine Elms. In the event the only through connection from Waterloo was by a single line joining with the South Eastern Railway (SER) line between London Bridge and Charing Cross at Waterloo East. Throughout the remainder of the nineteenth century Waterloo expanded in a piecemeal fashion, resulting in a ramshackle and thoroughly confusing collection of buildings and platforms. Consequently, in 1899 the board of directors decided that the only solution was a total rebuild.

Among London's great railway termini, Waterloo has no parallel in that it almost entirely dates from the first two decades of the twentieth century. In essence it is an Edwardian structure, built in the angular and restrained architecture of the time, which is described as either Imperial Baroque or the British Empire style. Its crowning glory, the imposing Victory Arch, is flanked by the figures of War and Peace, and high above Britannia holds the torch of Liberty. Opened by Queen Mary in 1922, it is a memorial to the company staff who lost their lives in the Great War. Internally, the station roof is a workmanlike design which lacks the sure hand and flare of the great Victorian engineers, the grandeur of Paddington or St Pancras. Even so, it more than makes up for this in the sheer acreage of glass.

In the ensuing decades Waterloo has been notable for the coming and going of the boat trains connecting with the great ocean liners docking at Southampton. It was from here that passengers travelled to join the *Titanic* on its ill-fated maiden voyage. The bow-shaped concourse has also echoed to the clatter of the be-hatted race-goers on their way to Ascot or Sandown, the wailing sirens of wartime, and the ebb and flow of a never ending tide of commuters. In 1948, on the occasion of the station's centenary, H. G. Davis wrote in the British Railways commemorative booklet that Waterloo 'might be described as a town in itself.'

Waterloo Station Through Time is the sixth title in this series celebrating the lives of London's greatest railway stations.

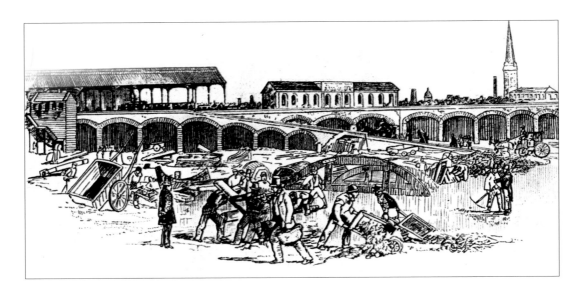

Old Waterloo

The original station of 1848, as seen from the north side. It is perched high above the surrounding ground on a series of brick arches and was accessed via ramps to either side. *Below*, this plan from 1895 shows the original station, which had become known as the Central Station, in the centre with the buildings arranged alongside the tracks. The spur from the South Eastern line and Waterloo Junction Station, later Waterloo East, can be seen crossing over Waterloo Road to enter the Central Station. In effect Waterloo consisted of three stations, each with their own passenger facilities, access roads and cab yards. Note the coal stages and turntable on the north-west side, located between Griffin Street and York Road. For comparison with the rebuilt twentieth century station, see the 1948 plan on page 16.

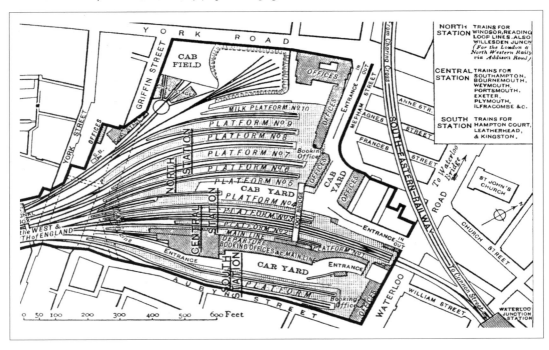

The 19th Century Station

> We got to Waterloo at eleven, and asked where the eleven-five started from. Of course nobody knew; nobody at Waterloo ever does know where a train is going to start from, or where a train when it does start is going to, or anything about it.

So wrote Jerome K. Jerome in his classic jaunt *Three Men in a Boat*. First published in 1889, this description of the chaos and confusion at Waterloo would have struck a chord with anyone who passed through it at the end of the nineteenth century. It is significant that this was also the year in which the directors of the LSWR decided on a complete rebuild. The main cause of Waterloo's descent into disarray had been twofold. Firstly there was the expectation that it was to be no more than a through station on a line into London and, secondly, the unanticipated growth in traffic far outstripped the best intentions of the railway company.

The extension of the line from a spur near Nine Elms consisted of four lines of track carried by more than 200 brick arches on a route that snaked around Lambeth Palace and the Vauxhall Gardens. The lines passed over twenty-one roads, with the largest span of 90 feet crossing the Westminster Bridge Road on a skew. The original station, opened on 11 July 1848, stood where platforms 7 to 12 are now. It occupied around ten acres of land and was laid out as a through station with two arrival and two departure platforms sheltered by two 140-foot roof spans. The platforms were 300 feet in length, although this was doubled not long after the station opened. The first buildings were of timber and aligned with the platforms, with the access ramps running up either side of the rails.

In the early days there were thirty-four out-going and thirty-four incoming trains each weekday. The locomotives didn't enter the station at first as the company employed a system known as 'roping'. Incoming trains stopped at a platform by the Westminster Road Bridge, where tickets were collected. The locos were uncoupled and a rope attached between the leading carriage and loco. Once sufficient momentum had been established, the rope was released and the carriages coasted into the station to be arrested by the guard's handbrake.

The unrealised schemes to extend the line left the station in a state of limbo. Buildings were erected on the west side, with a new cab yard running up from York Road. Near York Road there was an engine shed, sidings and a turntable on a spur, but access to the river was blocked by Goding's Lion Brewery and goods traffic continued to use Nine Elms. In 1854, the London Necropolis & National Mausoleum Company commenced operations from a siding and platform on the east side of the approach, near the Westminster Bridge Road. This unique railway

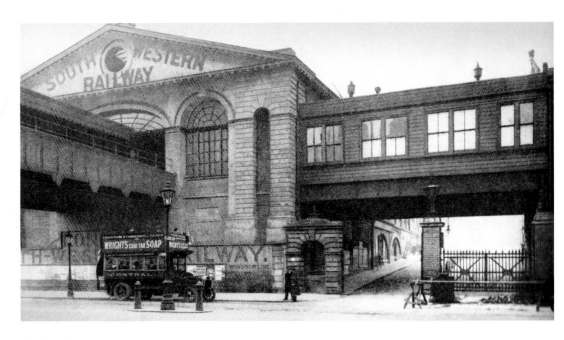

Waterloo Road

The LSWR's Central Station facing on to Waterloo Road, with the bridge for the single track coming from the South Eastern line. The entrance ramp is to the right and passes under a wooden linking structure. As shown *below*, the bridge remains, although it ceased to carry rails in 1925 and provided pedestrian access to Waterloo East until the recent construction of the higher tubular footbridge. The bridge in the background is the line to Charing Cross.

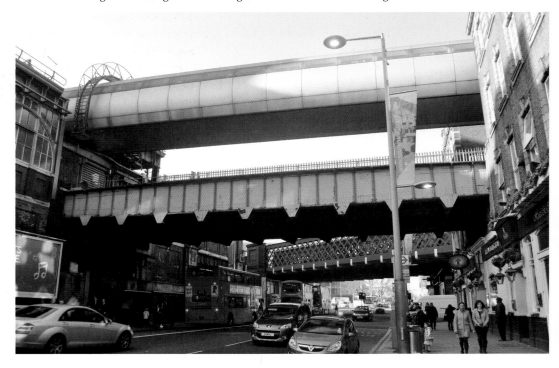

service took coffins and mourning parties to the new cemetery at Brookwood – *see page 51*.

Within ten years the number of trains using Waterloo had doubled and in 1860 four platforms were added on the north-west side for the Windsor traffic. Accordingly, this area became known as the Windsor Station. It was separated from the main station by its own cab yard and incline. The connection to the Charing Cross to London Bridge line was completed in 1870, with a single-track bridge passing over Waterloo Road and into the main station. Then, in 1878, more platforms were added on the south-east side to serve the suburban trains, creating what became known as the South Station, with its own offices and refreshment rooms. At about this time new booking offices and refreshment rooms were opened in a 300-foot frontage on Waterloo Road and with this, in effect, there were three stations on the wedge-shaped site, with the original one known as the Central Station.

To further confuse matters, the patriotic railway staff christened the southern station 'Cyprus' when the island was ceded to the British. In 1885 the North Station was erected as a continuation of the Windsor Station towards York Road, and this was labelled 'Khartoum' to mark the death of General Gordon in the Sudan, although it was sometimes also called 'Abyssinia'. This brought the number of platforms to eighteen, still served by the original four approach lines until two new ones were added in 1892. By the time Jerome K. Jerome's threesome, plus dog, were searching for their train in 1899, the station's disparate parts were known by a variety of names and the eighteen platforms shared a bewildering numbering system starting with Platform 1, for the main departure platform on the Central Station, only going up to 10 on the north side and completely ignoring the suburban platforms on the South Station. Waterloo had become the butt of countless jokes and cartoons published in the likes of *Punch*. One critic described it as 'a mighty maze without a plan' and another as 'the most perplexing railway station in London'.

It certainly cannot said to be the most convenient, but the South Western Company can at least boast that they own the largest terminus in London. Such as it is, however, it is probable that the Company and public will both have henceforward to make the best of it. To recast so huge a structure with 100,000 passengers and 700 trains in and out every day of the year is a simple impossibility; a task that unless the population of London all take holiday for a twelve-month is hardly likely to be so much as attempted.

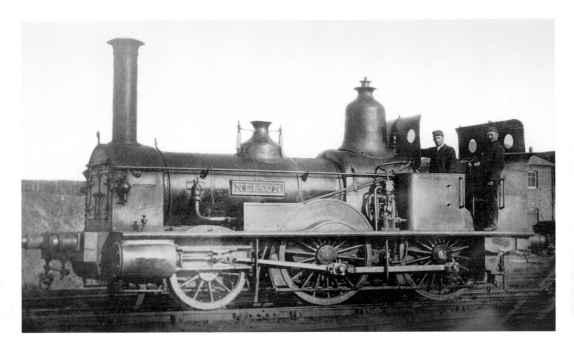

Early LSWR Motive Power

In the 1850s the LSWR's chief engineer, Joseph Beattie, designed a series of six-wheeled locomotives with the water tank set below the footplate level. Between 1852 and 1859, twenty-six locomotives were built to six different designs, including the 2-4-0WT Nelson class of 1858. From these Beattie evolved the Standard Well Tanks, which were introduced in 1862. *Below*, the 2-4-0 *Ajax* appears to have a double chimney, but the second one is actually a vertical jet condenser. (*CMcC*)

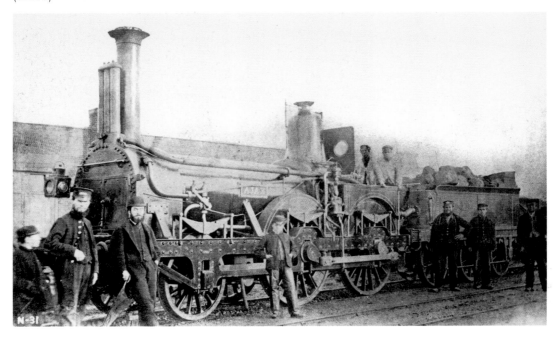

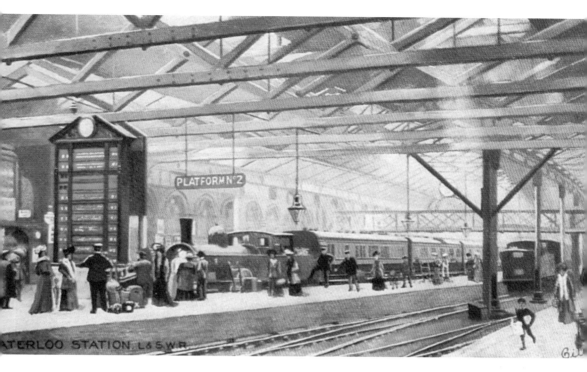

Platforms *c.* 1905

Contemporary postcard in the Raphael Tuck 'Oilette' series, depicting Platform 2 of the Central Station with an LSWR tank engine preparing for departure. On the left is the departures indicator board. *Below*, the gentle curve of Platform 3, which had been widened in 1902. Locos are an Adams T3 class and a Drummond S11 class, No. 403. Note the footbridge in the background which linked platforms 2, 3 and 4 as well as spanning the central cab yard to Platform 5.

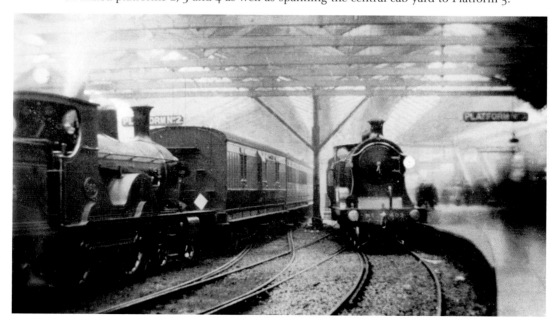

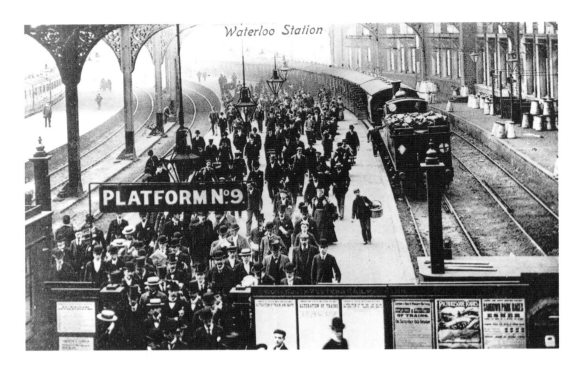

Waterloo Station

Arrivals and Departures

Passengers pour through the barriers on a busy Platform 9 of the North Station. The noticeboard has posters for special excursion trains to take race-goers to Sandown Park in Esher, Surrey, as well as notices concerning alterations to train services. Note the churns lined up on the Milk Platform, to the right, and the side wall of the North Station building. *Below*, a T9 class loco at the end of Platform 3 of the Central Station.

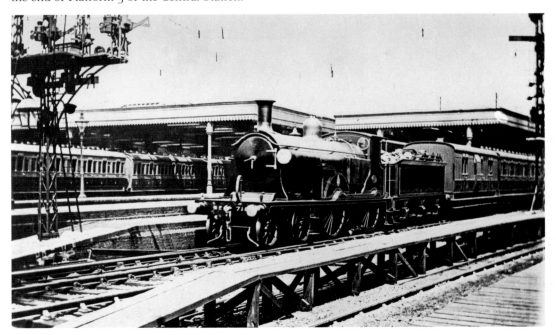

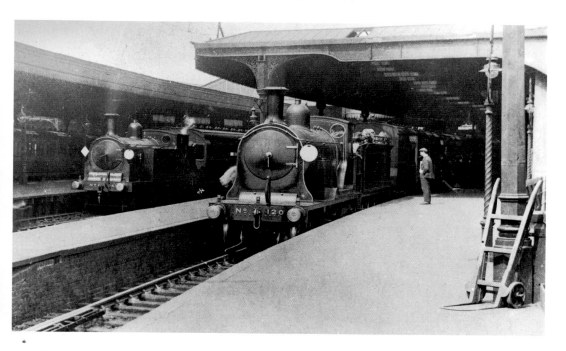

Departures

Above, the view from Platform 1 of the Central Station, taken around 1905 or so. No. 120 is a T9 class, and behind it No. 246, an M7 class, waits at Platform 2. *Below*, an interesting postcard showing engine No. 417, a Drummond L12 class built in 1904, departing from Platform 2. In the background work is in hand on dismantling the roof between the central platforms and the South Station as the building work progresses northwards.

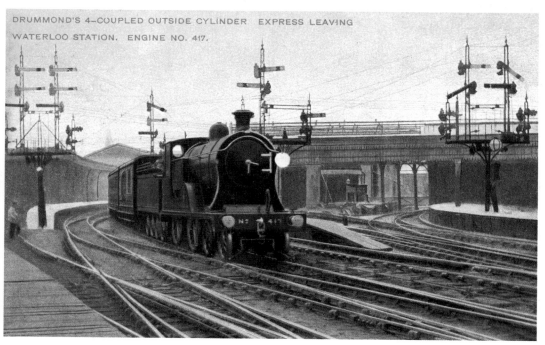

DRUMMOND'S 4–COUPLED OUTSIDE CYLINDER EXPRESS LEAVING WATERLOO STATION. ENGINE NO. 417.

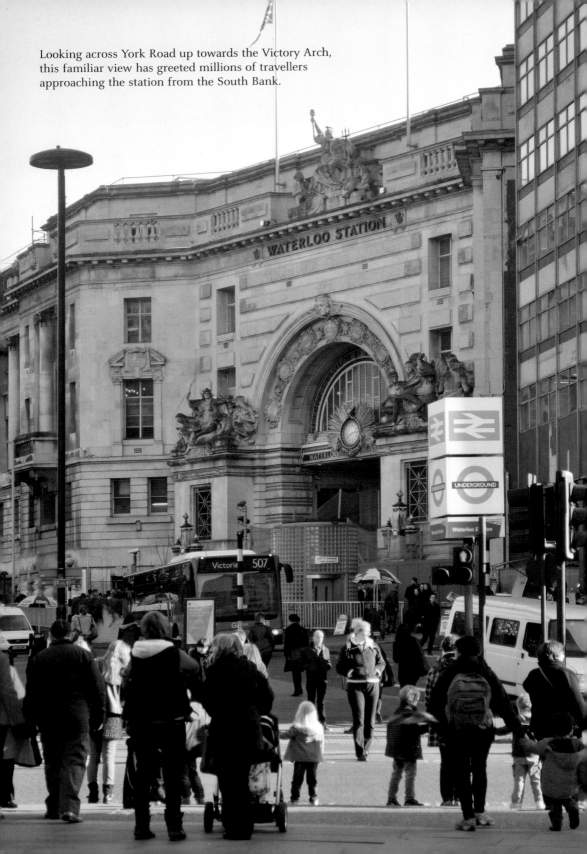

Looking across York Road up towards the Victory Arch, this familiar view has greeted millions of travellers approaching the station from the South Bank.

A New Waterloo

The Waterloo that emerged in the first two decades of the twentieth century bore little relation to the mishmash of structures that had made up the old station.

The initial phase of the 'Great Transformation', as it became known, was the acquisition of additional land to the south of the station and adjacent to the track, as it was also intended to widen the lines as far as Clapham Junction. This entailed the loss of several streets, the Catholic All Saints Church on the junction of York Street (now Leake Street), and the displacement of 1,750 residents. By 1903 the land had been cleared and within two years the first of the great steel columns supporting the new roof were in place. To minimise disruption, the rebuilding was carried out in stages and in 1909 the first section of the South Station – it was hard to shake off the old names – was opened to rail traffic.

By the end of the decade a new entrance off Westminster Bridge Road was ready and the main entrance from Waterloo Road was closed. Having started on the southern end the work gradually progressed northwards, one step at a time. The next phase was to rebuild the original central section, and by the end of 1913 the old general offices had gone. Shortly afterwards eleven platforms were in use, including those on ground formerly occupied by the old office buildings. Inevitably the First World War brought delays, but by 1919 the new escalators were operating between the concourse and the trains below ground level. The famous four-faced clock was also placed in its position above the cab road between Platforms 11 and 12.

Continuing northwards, work went ahead on a series of small buildings erected between Platforms 15 and 16 to provide offices for the stationmaster and staff. Nicknamed 'the cottages' during construction, these buildings were collectively referred to as the 'Village'. They also housed the Lost Property Office and, later on, the station announcer's box, placed at the end of the flat roof. Generations of rush-hour travellers would come to associate the station with the twice-daily programme of cheerful music played over the loud speakers. With the advent of electrification of the suburban lines, instigated by the LSWR in 1913, Waterloo also gained a reputation as one of London's cleaner stations – see page 42.

Between 1919 and 1922, the last phase of the rebuilding was carried out when the new front offices were linked to those lining the approach from York Road. This included the imposing pedestrian entrance, the Victory Arch, named in tribute to the members of staff who lost their lives in the war (not to commemorate Wellington's victory at Waterloo,

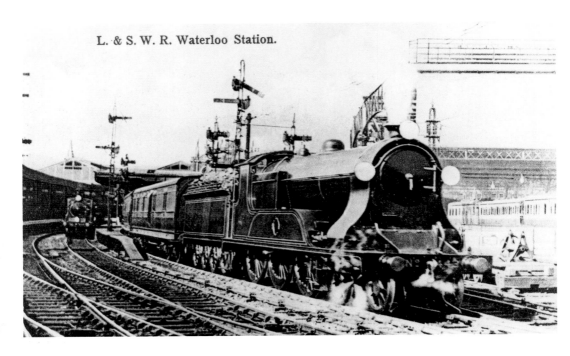

L. & S. W. R. Waterloo Station.

Waterloo Sunset

Postcard view of No. 443, one of five Drummond T14 class locomotives built at Eastleigh in 1911. These 4-6-0 locos hauled express passenger trains and continued in service under the Southern Railway. Evidence of the rebuilding can be seen in the background. *Below*, this map of the new Waterloo Station reveals a wealth of detail. Note the vehicle tunnel under the signal box (*see page 49*), the News Theatre located beside Platform 1, the station offices, and also the hoist for the WCR towards the top of the plan.

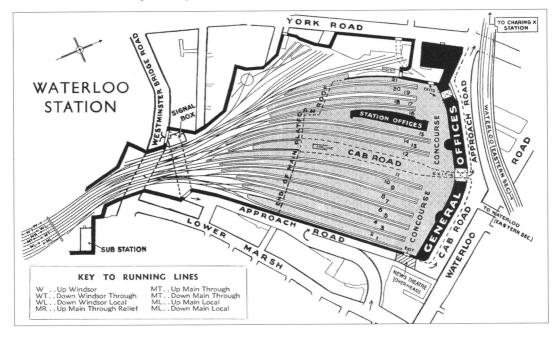

as is sometimes suggested). The sculpture on the left side of the entrance depicts Bellona, the Spirit of War, in scaled armour straddling the world to deal out death and destruction, while the one on the right is of Peace bearing an olive branch. Above them, the name of the station is flanked by LSWR monograms, and Britannia brandishing the torch of Liberty. This archway was the focal point for the formal opening for the completed station by Queen Mary on 21 March 1922.

Unlike many of London's great termini, the guiding hand behind its design remains relatively unknown. In 1901 the LSWR's chief engineer, J. W. Jacomb-Hood, had travelled to the USA to examine their take on station design and layout. The plans he drew up set out the station as we know it today, the platforms laid out like a fan with the wide concourse curving across the end. Jacomb-Hood had envisioned twenty-three platforms but in the event this was reduced to twenty-one thanks to the retention of the more recent and perfectly satisfactory roof over the North Station. Jacomb-Hood died in 1914 and the work was completed by A. W. Szlumper.

The Portland stone frontage of the station is in a deceptively clean style known generally as Imperial Baroque. It has the promise of Art Deco's love of angular hard edges while incorporating classical motifs such as the columns, decorative faces, heads and swags to be seen around the buildings. These architectural features, including the Victory Arch, were the work of James Rob Scott.

Because of the position of the nearby line from Charing Cross to London Bridge, it is difficult to obtain a clear view of the exterior. For many travellers coming up the incline from York Road, the Victory Arch is their 'main' entrance and more than any other part of the station this corner has come to represent the whole. The actual main entrance is under the bigger canopy at the north-east corner and leads into the booking hall. The wide central entrance, opposite Platforms 11 and 12, was for vehicles accessing the cab road. Inside, the concourse was 120 feet deep originally and stretched in a gentle arc along the 770-foot length of the station. In addition to the usual collection of bookstalls, there were departure and arrival boards, an enquiry office and, within the main block, refreshment rooms, lavatories, a luggage hall, and waiting rooms. The upper floors were occupied by company offices. Later additions included a branch of the National Provincial Bank, opened in 1924, and the News Reel Cinema, which was perched above the Approach Road entrance beside Platform 1. (Both of these had their equivalent at Victoria Station.) In recent years, the station's openness has been compromised by a wall of barriers and advertising hoardings that has cut off the view to the platforms and left the concourse feeling like a canyon. The latest addition is the retail balcony along the main building.

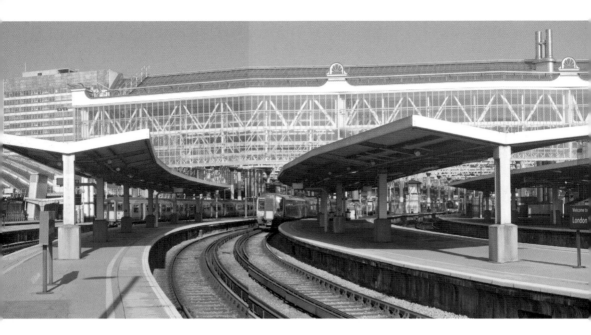

The 'Country' End

Taken from Platform 15, this stitched-together panorama looks north-east across the country end of the station in March 2013. The roof of the Eurostar terminal can be glimpsed on the left. *Below* is a similar view, this time from the A Box at the turn of the century. A wooden extension from Platform 4 of the Central Station continues as far as the signal box. The North or Windsor Station is set back on the left, along with the sidings going towards York Road. The South Station for suburban services is shown on the far right. Note the tall semaphore signals.

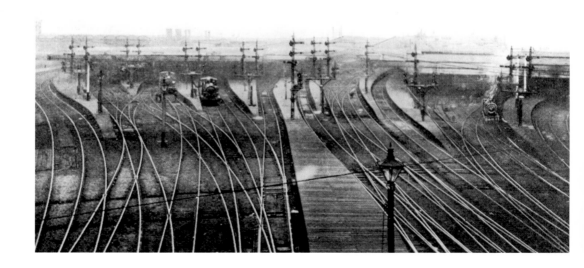

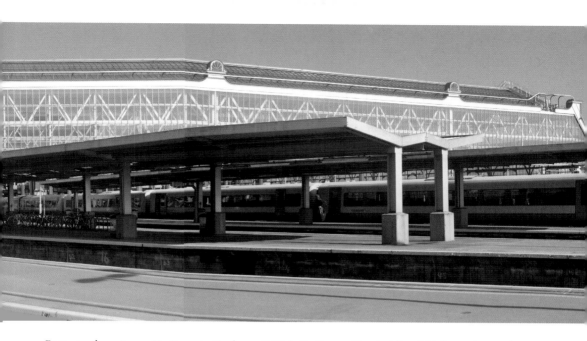

Postwar departure, *Sir Francis Drake*, a British Railways liveried Lord Nelson class 4-6-0, No. 30851, on its way to Bournemouth against the backdrop of the Country end. For much of the twentieth century the station's structural steelwork was painted green and, as shown here, the window panes covered by soot and smuts lacked the clarity of their modern replacements.

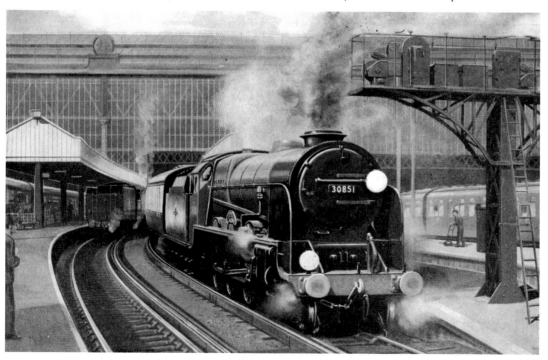

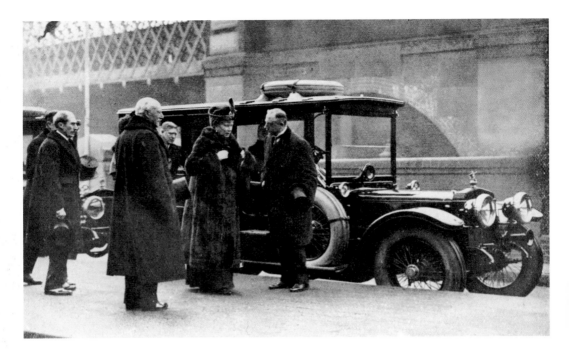

The Official Opening

On a dull and chilly 21 March 1922 Queen Mary came to Waterloo, as the King was indisposed at the time, to officially open the completed station. *Above*, the Queen is greeted by the LSWR's chairman in front of the Victory Arch, formally opened by severing a royal blue ribbon set across the entrance. The bridge in the background carries the Charing Cross line over York Road.

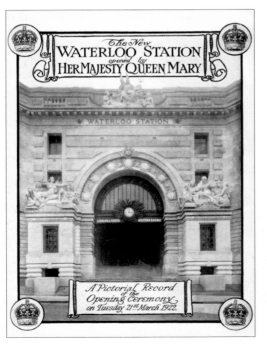

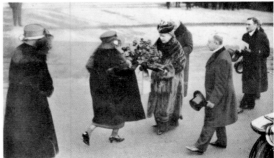

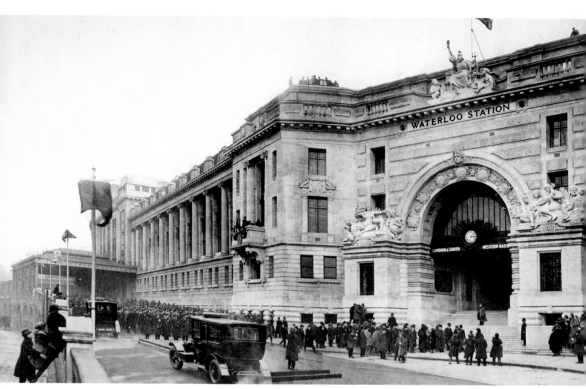

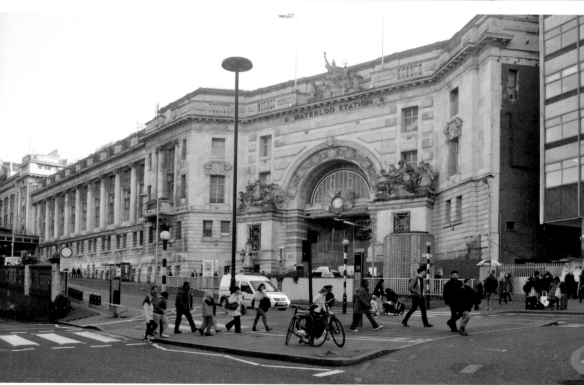

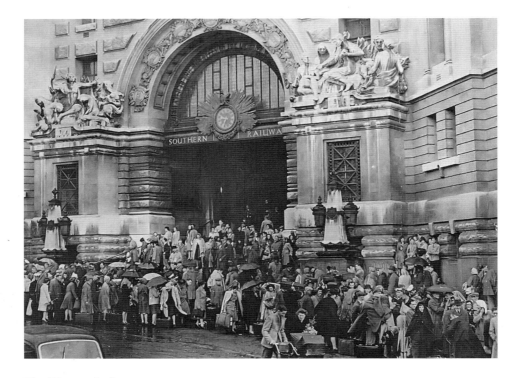

The Victory Arch

Dedicated by the LSWR to the members of staff who lost their lives in the First World War, the arch is the primary entrance for countless travellers. Hundreds of them are shown huddling from the rain in this 1950s photo. (*RMAC*) *Below*, the locations of the military campaigns are carved into the arch. Although Waterloo was handed over to the Southern Railway at the end of 1922, the LSWR monograms remain on either side of the station name.

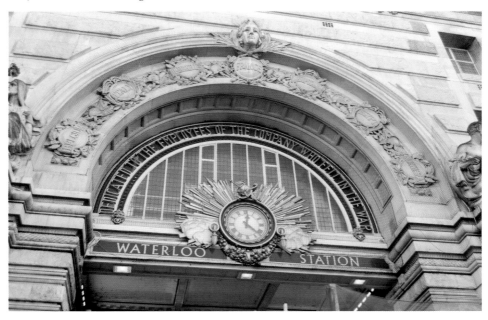

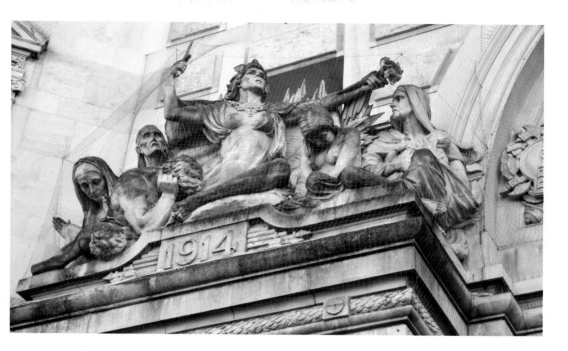

The warlike figure of Bellona dealing out death and misery is countered by Peace on the other side of the Victory Arch. *Below*, Edwardian opulence, although the obelisk lamps were not in place for the 1922 opening. *Left*, decorative ironwork, possibly a lamp fitting, near the main entrance.

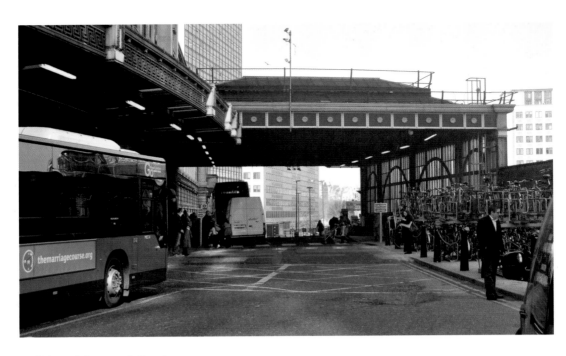

Cab and Approach Roads

Above, looking northwards towards the approach slope with the vehicle entrance on the left, behind the bus. *Below*, taxi drivers and chauffeurs waiting beside the main entrance leading into the booking hall, early 1960s. (*RMAC*)

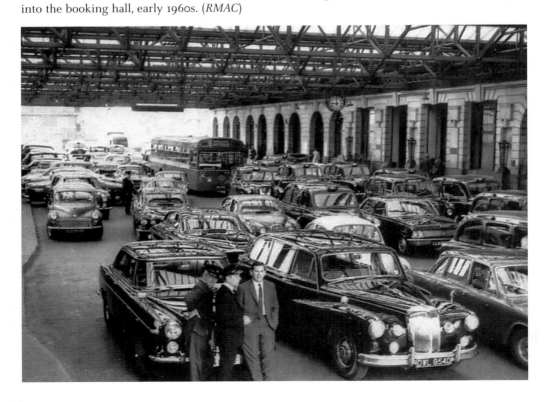

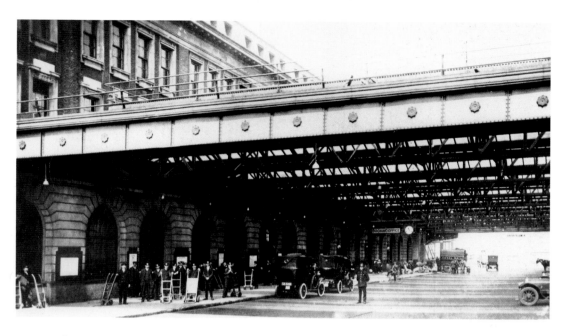

Main Entrance Canopy

The large main entrance canopy viewed from the south. Rebuilding work is continuing on the far side and the decorative features, *shown on page 23 and opposite*, have yet to be added. The glass sides of the extensive canopy area are seen from the link bridge crossing Waterloo Bridge Road. At street level the arches were occupied by parcel office and stores. The redundant link bridge is now only used by railway staff for storing bikes.

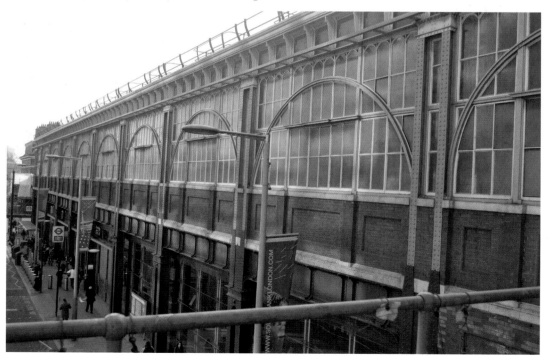

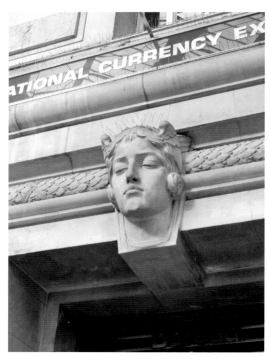

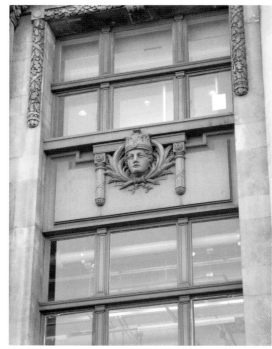

Designed by James Rob Scott, these typically Edwardian head motifs appear on several parts of the station building. *Left*, on the concourse beside the Victory Arch, and *right* as window decoration. *Below*, main entrance detailing and this unexpected relic from the past preserved beneath a bouquet of plastic flowers.

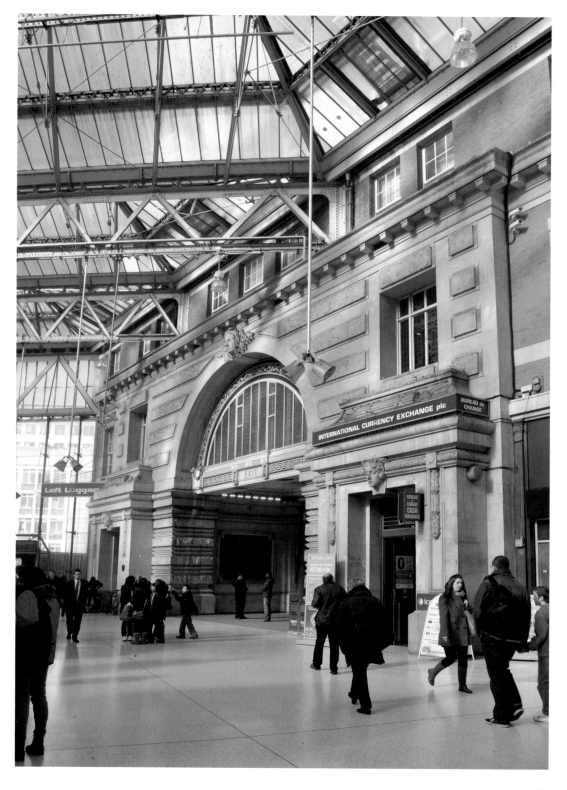

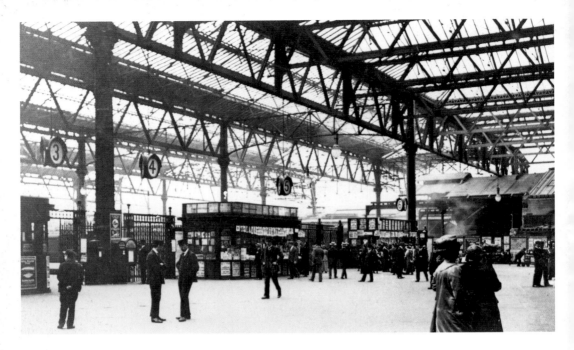

Station Roof

Shown *above* during the rebuilding, it was described by John Betjeman as 'neither elegant, nor offensive'. The Edwardian engineers did a workmanlike job covering the 24 acres with a ridge and furrow latticework of steel and glass, running at right-angles over the concourse and then transversely above the platforms. The octagonal support columns are substantial, although the modern paintwork and new glazing create a spacious feel.

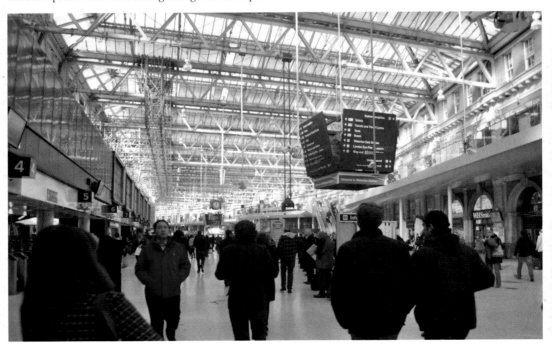

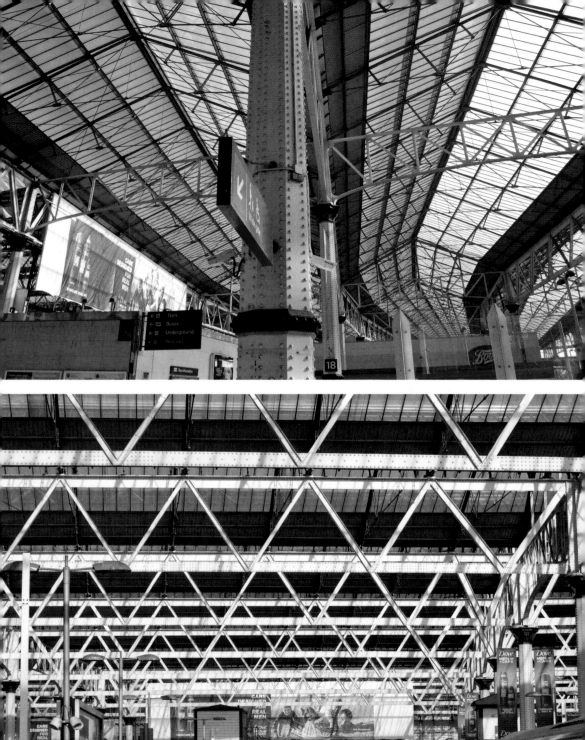

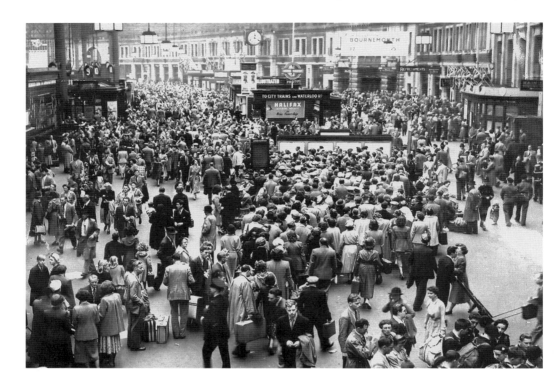

Station Concourse

Viewed from the south end of the concourse. *Above*, holiday crowds queue patiently for their trains in the late 1950s. (*RMAC*) *Below*, a quieter moment on a weekday afternoon in 2013. Note how a wall of hoardings has risen above the barriers to block off the view of the rest of the station. The Victory Arch is in the distance.

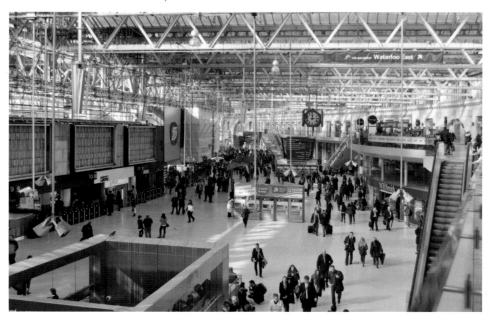

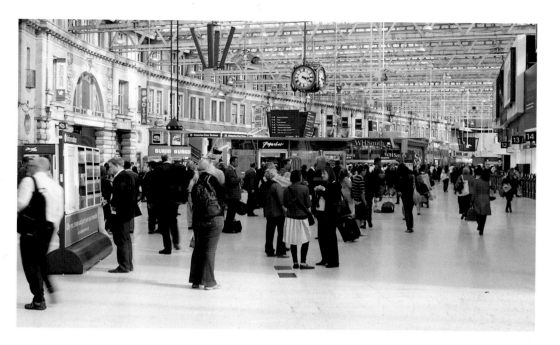

The New Retail Balcony

Before and after: The new first floor balcony was completed in May 2012 in time for the anticipated Olympic congestion. Although it has greatly increased the retail area on the concourse, as well as improving the step-free access to Waterloo East, it does obscure the view of the station building. (*Network Rail*)

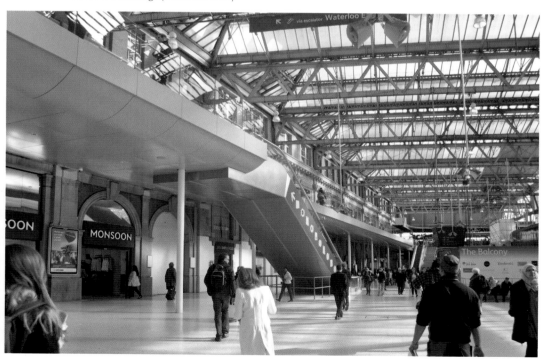

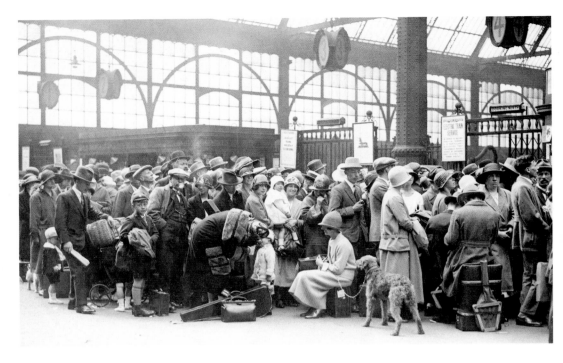

Suburban Platforms

Passengers lining up for holiday trains, with Platforms 1, 2 and 3, plus the south-western side of the station in the background. Southern Railway notices carry information regarding August Bank Holiday Excursions and Electric Train Services. With the exception of one man and a dog, everyone, including the youngsters, wears a hat. As shown *below*, you can't get the same unobstructed view with the more substantial barriers to the Epsom and Surbiton trains on Platforms 2 and 3.

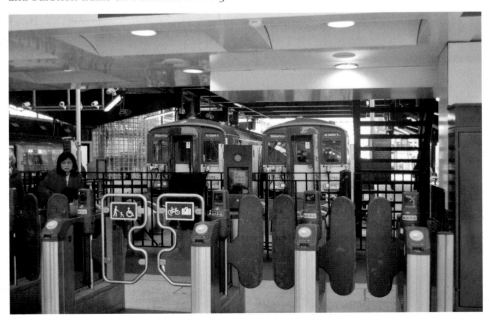

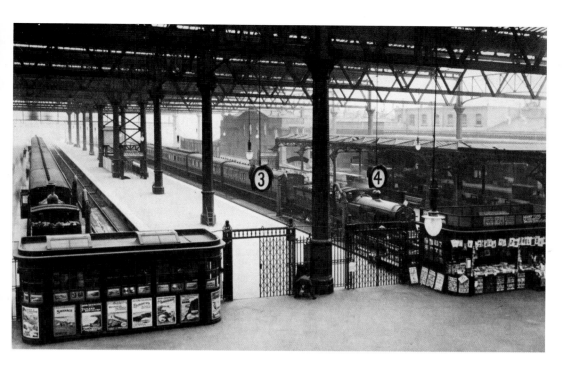

Platforms 3, 4 and 5

In this early image, *c.* 1910, the platforms are functional but the old canopy and station buildings still stand in the background. LSWR posters advertise excursions to south coast resorts. Note the staircases down to the 'City Railway'. *Below*, the view is obscured by the modern electronic information board.

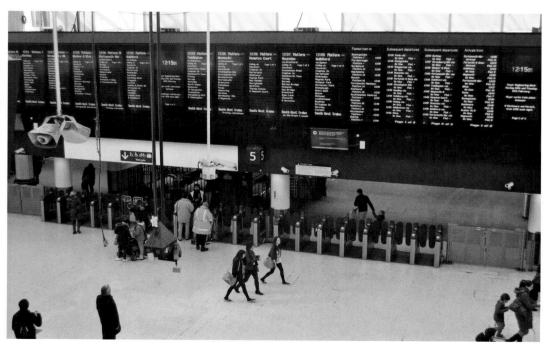

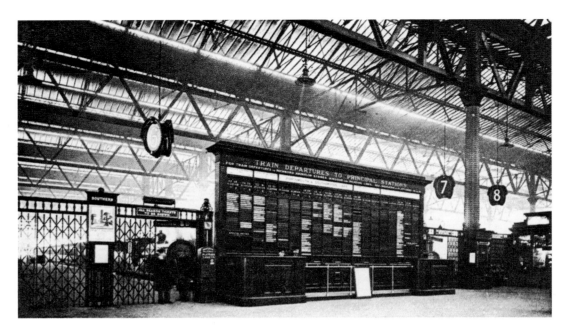

Train Departures Information Board

The Southern Railway Departures Board was located between Platforms 6 and 7. Divided into nineteen columns, the information was altered mechanically by the insertion of a card stencil through which a system of push rods turned the station names. A similar Arrivals Board, divided into twelve columns plus a central Boat or Special Trains panel, was between Platforms 13 and 14. The mechanical system was replaced by British Rail in 1977 as part of the station's modernisation.

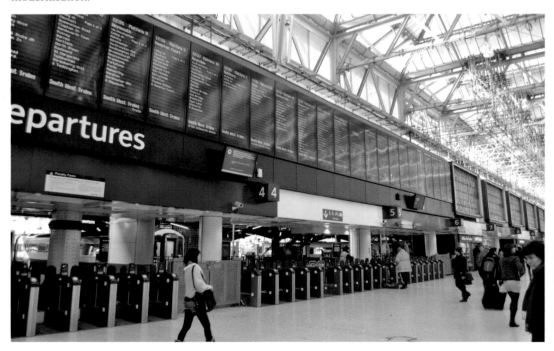

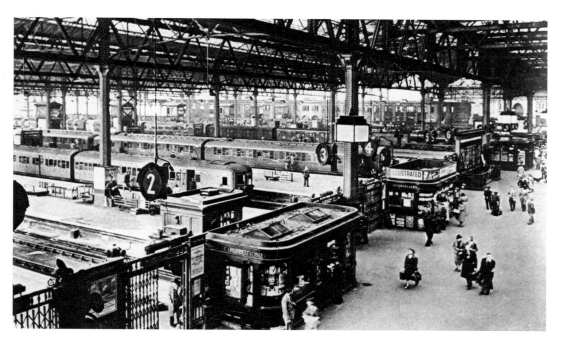

Northern Platforms

A post-war view across the platforms towards the northern or Windsor end of the station, with the 'Village' station offices between Platforms 15 and 16. In the foreground an electric suburban train sits at Platform 3. Note the confectionery and newsagents booths with their rounded corners, and also the Departures Board between 6 and 7. *Below*, the sun pours in on Platform 16 and the South West Trains 12.28 for Windsor and Eton.

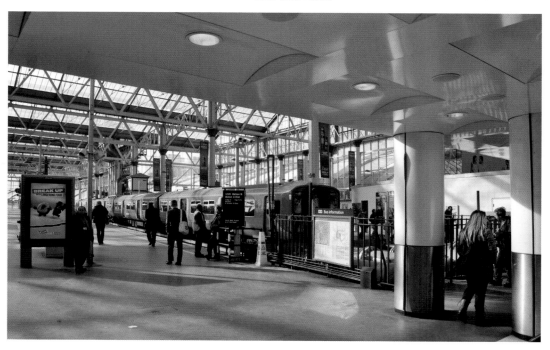

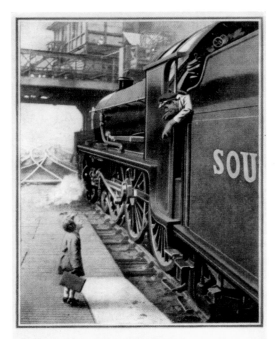

"Yes, I always go South for Sunshine by SOUTHERN "

Boy and Engine

Arguably the most famous railway poster of all time. Based on a 1924 publicity photograph by Charles E. Brown, it features a little boy talking to the fireman of an N15 King Arthur class loco, *The Red Knight*, with Waterloo's 'A' Box in the background. Produced in several versions by the Southern Railway, it was even mimicked by the LNER in a modernist style. (*CMcC*)

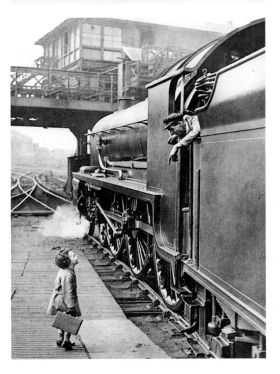

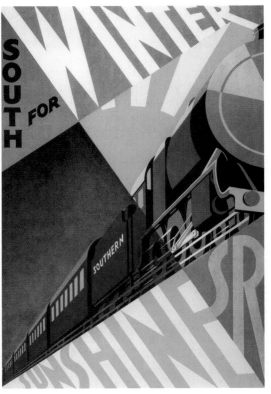

Unlike the other railway companies the SR was predominantly a passenger service. Fortunately it was blessed with more than its fair share of coastal resorts and the publicity department played heavily on the association between railway and sunshine.

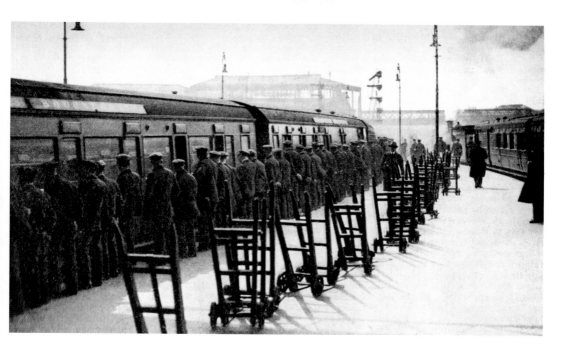

Lining Up

A row of Southern Railway porters waiting to receive luggage from a holiday special arriving from Bournemouth. The nameplates on the coaches indicate that the train was divided to run in several portions. Note the 'A' Box and gantry in the background. *Below*, a departing South West Trains service. The sun still shines on Waterloo but the porters are nowhere to be seen.

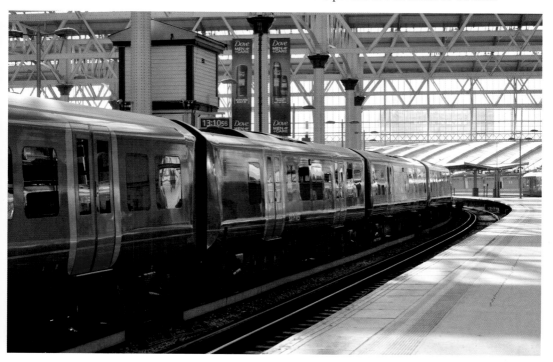

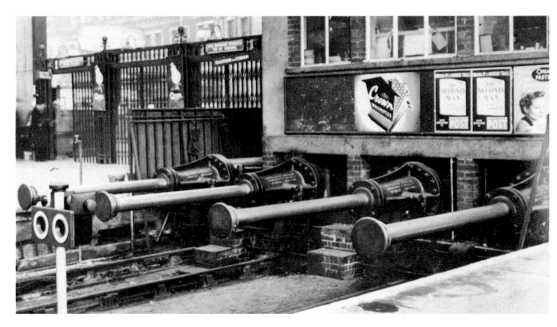

Reassuringly beefy Ransomes & Rapier hydraulic buffer stops at the end of the platforms, as featured on a Wills cigarette card in their Railway Equipment series, and still in situ.

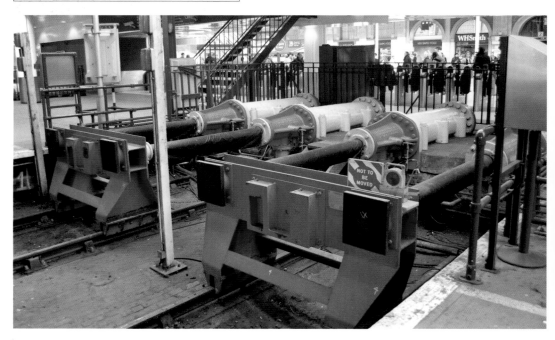

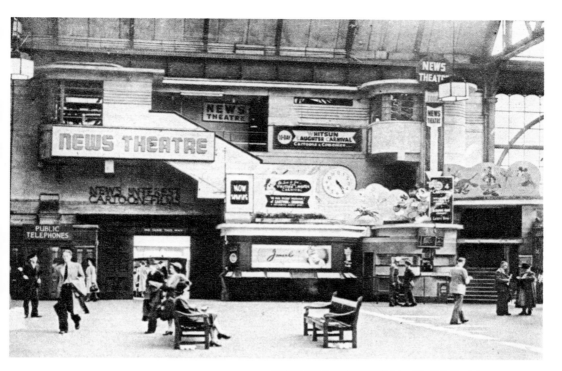

Waterloo Miscellany

Above: The News Theatre opened its doors in August 1934 and offered 'news interest and cartoon films' to entertain the traveller with time on their hands. It was located at the eastern end of the concourse beside Platform 1 and extended out over the approach road on that side of the station.

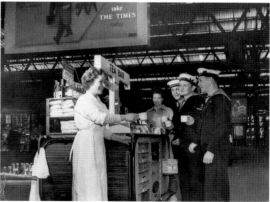

Right: A thoroughly modern tea bar photographed in action in the early 1960s. The sailors might have preferred something a little stronger, and the surrounding area was notorious for other entertainments, earning the nickname of 'Whoreterloo'. (*RMAC*)

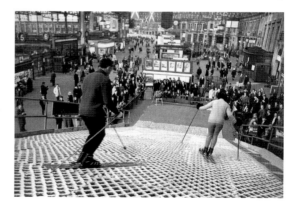

Bottom: A dry ski slope was set up on the concourse in 1967 as part of the Scottish Holiday Fortnight, an event organised by British Rail and the Scottish Tourist Board. On another part of the station, a haggis-eating competition was in progress.

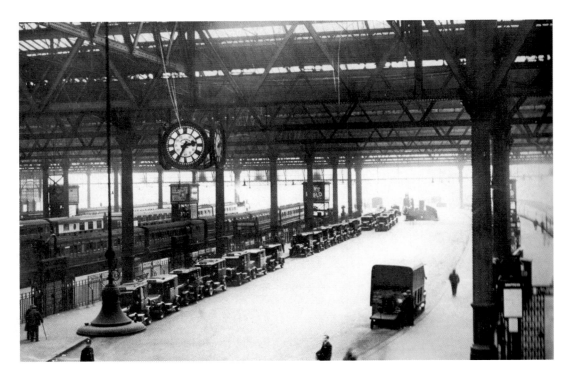

The Cab Road

Photographed in the 1930s, a row of black cabs line up in the wide road area between Platforms 11, used for important boat trains, and 12 which, with 15, was mostly given over to parcels traffic. *Below*, modern cabs waiting their turn on the Approach Road.

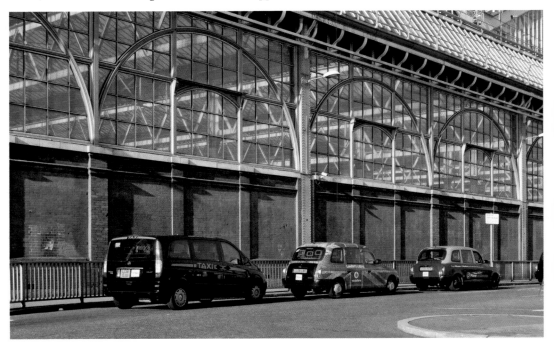

A Royal Mail Leyland truck beside Platform 12 in 1986. The Village buildings, including the Stationmaster's offices, are in the background. Note the announcer's shack on the flat roof. (*Kevin Lane*) *Below*, the famous four-faced station clock above the cab road was built by Gents of Leicester in 1922.

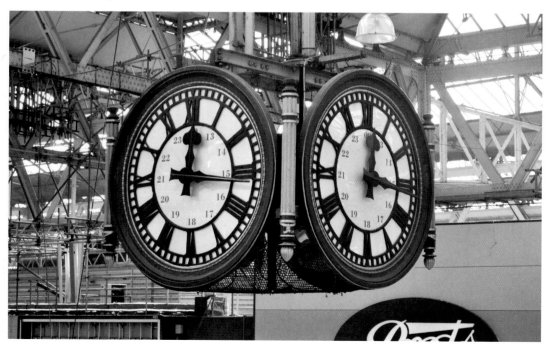

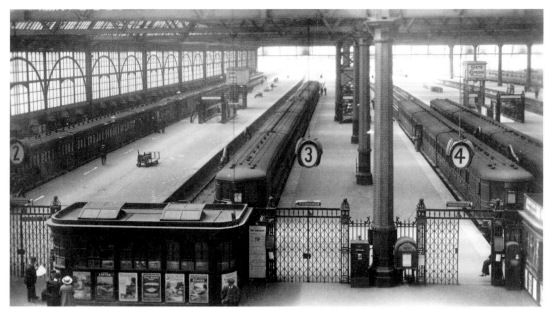

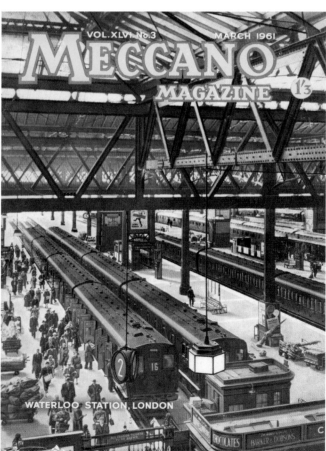

Electrification of Suburban Services

Suburban trains at Platforms 3 and 4. The signs above the gates say Shepperton and Teddington. The electrification programme was initiated by the LSWR in 1913 when the third rail system was adopted, the first trains running from Waterloo to East Putney in October 1915. The Kingston 'roundabout', the Shepperton, Hounslow loop, Hampton Court and Clayton lines saw electrification in the following year. After a decline in passenger journey numbers on suburban services, reaching an all time low of 23,000,000 in 1913, electrification brought an immediate increase, with 40,000,000 by 1918 and 50,000,000 by 1920. Under the Southern Railway the lines between Raynes Park and Dorking North via Leatherhead, and between Claygate and Guildford, were converted in 1925, and then in 1930 electric trains began to operate between Waterloo and Windsor.

The SR enthusiastically expanded the electric network to cover the area immediately south of London, plus Brighton, Eastbourne, Hastings, Guildford, Portsmouth and Reading by 1929. Other areas including Sevenoaks were electrified by 1939; the lines to the Kent coast came next; and, delayed by the war, the programme reached Southampton and Bournemouth in the 1950s and 1960s. *Above right*, a Senior Service cigarette card showing the control cabin of an electric express with the driver grasping the dead man's handle. *Below*: An electric train on Platform 3 in British Railway's times, *c*. 1960. (*RMAC*)

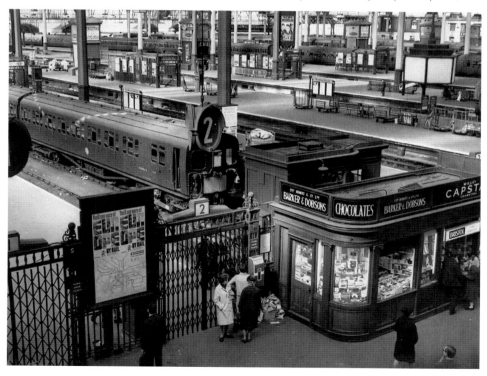

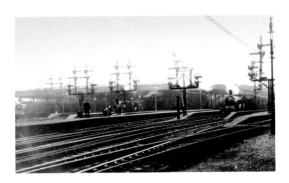

Signalling

Top left: The semaphore signal gantries on the end of each platform in this *c.* 1910 view looking towards the old Central Station. By the late 1880s Waterloo was handling up to 700 trains per day, and by the 1920s this figure had increased to over 1,000. Electric colour light signals were introduced in October 1936 and six signal boxes, including Waterloo's famous 'A' box, *opposite*, were scrapped and replaced by the new one – *see page 47* – which can be glimpsed in the background of the picture *left*. (*CMcC*) *Below*, a present day gantry with an incoming BR class 455 EMU, No.5718, operated by South West Trains.

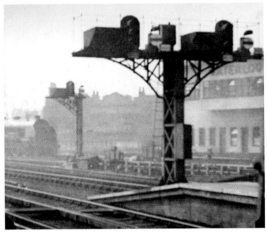

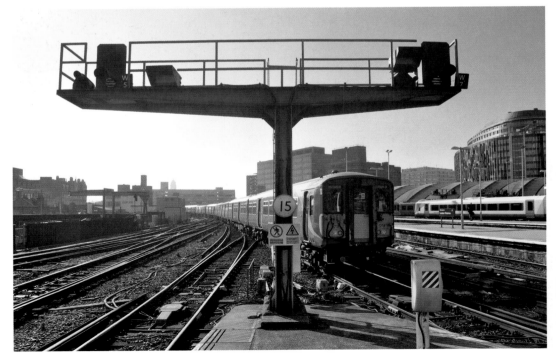

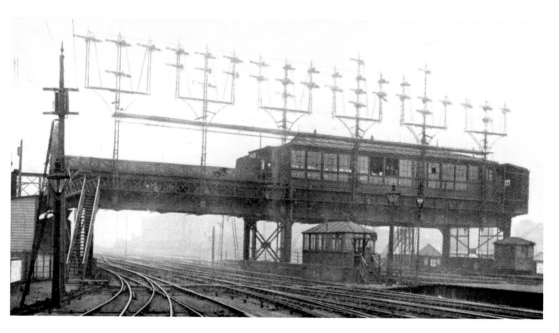

The 'A' Box

The first 'A' box of forty-seven levers was erected in 1867. It was replaced by one of 100 levers in 1874 and this was further enlarged in the 1870s and 1880s until the box had 226 levers. By the turn of the century, around 24,000 manual lever movements were being made each day by a team of sixteen signalmen. Recognising the strain that these men worked under, those reaching sixty were moved to quieter boxes with no loss of pay. *Below*, an interior view of the 'A' Box *c.* 1925.

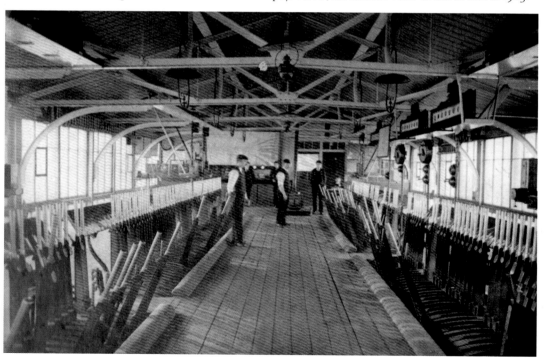

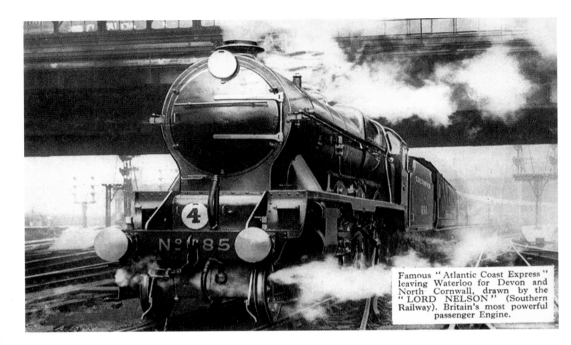

Famous "Atlantic Coast Express" leaving Waterloo for Devon and North Cornwall, drawn by the "LORD NELSON" (Southern Railway). Britain's most powerful passenger Engine.

Signal Box Departures

Above, Southern Railway's *Lord Nelson*, No. 851, passes under the 'A' Box gantry hauling the famous 10.50 Atlantic Coast Express. This passenger express service to Devon was inaugurated in July 1926. *Below*, an interesting interloper at Waterloo. As part of the British Railways engine exchange, the former LNER A-4 class *Seagull*, No. 60033, was lent to the Southern Region. It is shown leaving the station beside the new signal box during an Atlantic Coast Express test run with a GWR Dynamometer Car on 10 June 1948.

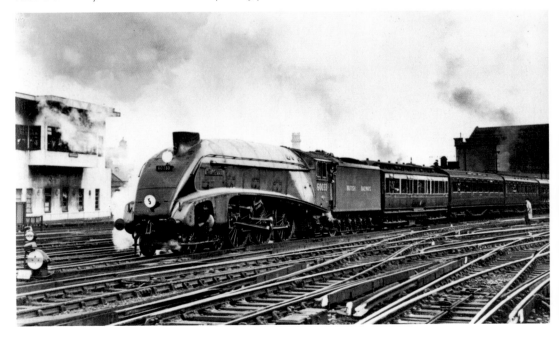

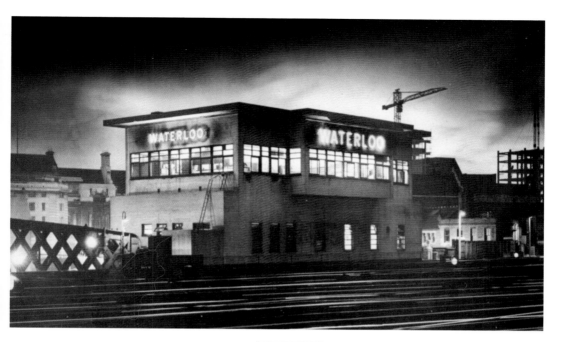

Waterloo's modern 'all electric' signal box went into full operation on 18 October 1936. Illuminated track diagrams indicated the position of each train and the bell codes and clanking of levers gave way to an 'uncanny quietness'. Located on the east side of Westminster Bridge Road, the concrete box was closed in 1990 and demolished to make way for the Eurostar terminal.

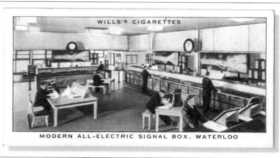

WILLS'S CIGARETTES

MODERN ALL-ELECTRIC SIGNAL BOX, WATERLOO

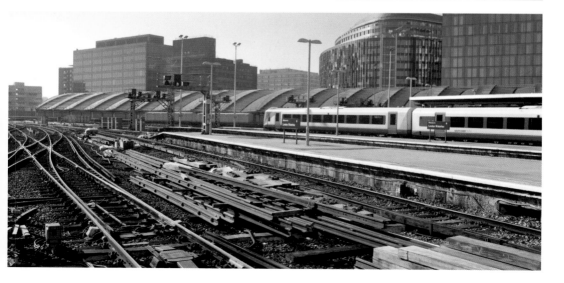

On the Tracks

Looking like 'so much spaghetti', according to John Betjeman, the eight running lines spread out their tendrils as they approach Waterloo Station. *Below*, a press photograph from July 1945 showing the crowds watching British Railway Southern Region engineers laying lengths of pre-fabricated track adjacent to Platform 5.

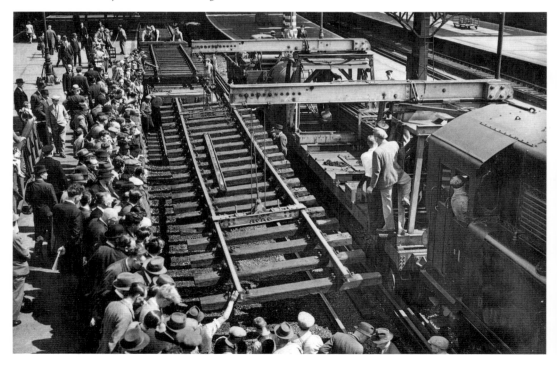

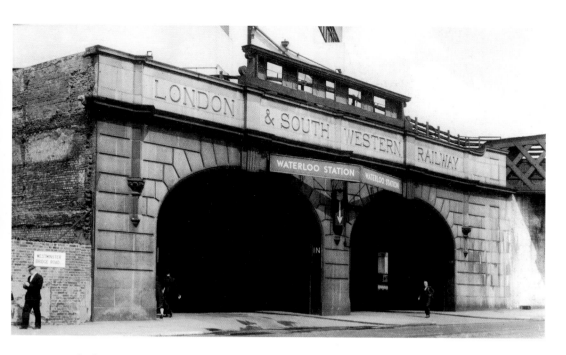

Beneath the Tracks

The entrance to the vehicle tunnel, which was located on the north side of the Westminster Bridge Road and passed under the lines to emerge on the south-east approach road. The 1936 signal box was built above it and can be seen at the top of the picture. *Below*, the magnificent curving steel girders supporting the line across the 90-foot span of Westminster Bridge Road.

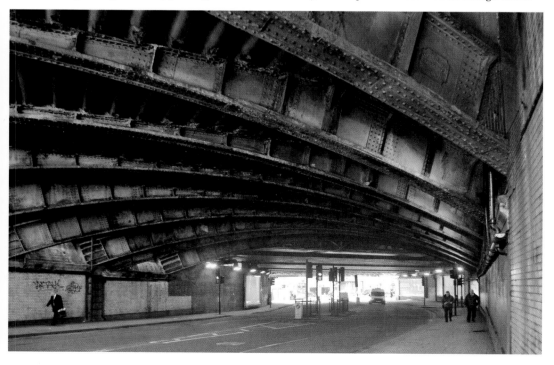

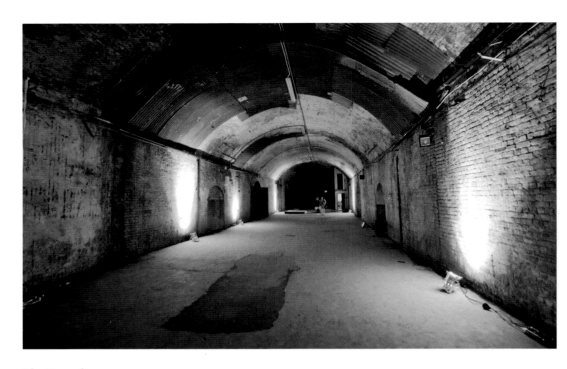

The Tunnels

One of the 'Old Vic' tunnels beneath the track. (*Nick Whiteacre*)

The Banksey Tunnel: Once a dark and disused cut-through for taxis passing under the railway lines, Leake Street tunnel was transformed into an *ad hoc* gallery by renowned graffiti artist Banksey for his 'Cans Festival' in May 2008. It is now an authorised graffiti zone.

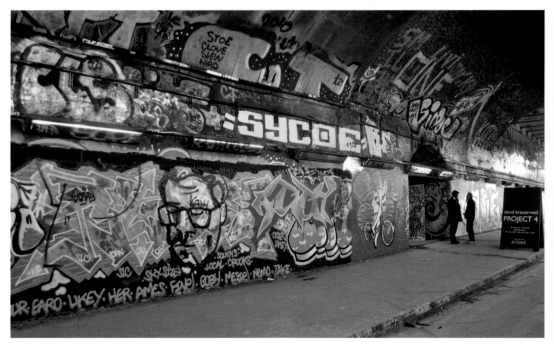

The Necropolis Railway

With London's existing graveyards running out of room, the London Necropolis Company was formed to provide burial spaces outside of the capital. A new cemetery was created at Brookwood, Surrey, about twenty-three miles to the south-west. At the time it was the largest cemetery in the world, with space enough for centuries to come. The London Necropolis Railway opened in November 1854 to take the deceased and mourning parties from Waterloo to the cemetery. Because of the sensitive nature of its clientèle, the station was run as a separate entity and was originally located on the southern side of the line, between Westminster Bridge Road and York Street (now Leake Street), with the brick arches converted into mortuaries and a three-storey office building alongside. The special trains ran on the LSWR lines as far as the NCR's branch at Brookwood, where the locos were decoupled and the carriages pulled by teams of black horses into the cemetery's north and south stations. When the LSWR wanted to increase the number of lines at Waterloo, the original station was replaced by a new purpose-built terminus on the opposite of Westminster Bridge Road, *right*. This opened for business in 1902 and continued in operation until the spur line and station were severely damaged during an air raid on the night of 16 April 1941. Only the main building remains.

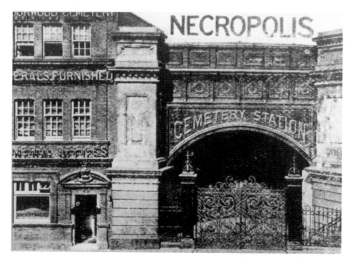

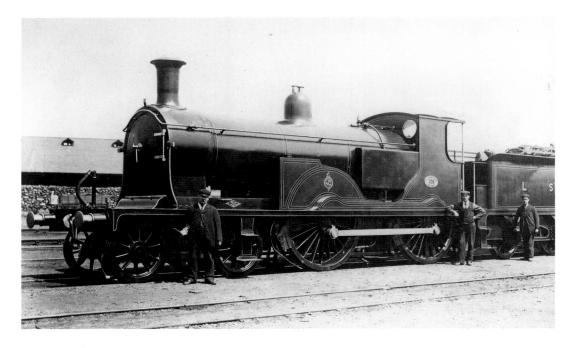

Drummond Locos

LSWR 708, one of sixty-six T9 class 4-4-0 locos designed by Dugald Drummond for express passenger work. It was built in 1899 by Dubs & Co. in Glasgow. There is one surviving T9, now operating on the Bodmin & Wenford Railway. *Below*: No. 245, a class M7 0-4-4T 'Motor tank' on display at the NRM in York. Designed by Drummond, it is one of 105 built between 1897 and 1911 for passenger services. No. 245 was withdrawn by British Rail in 1962.

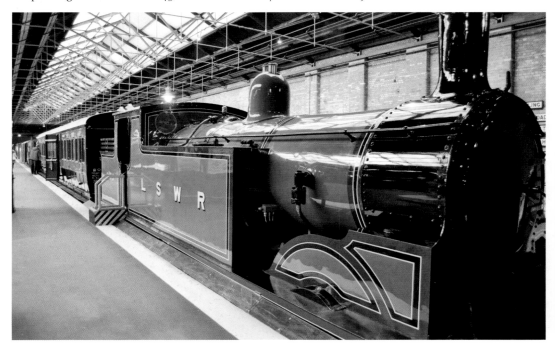

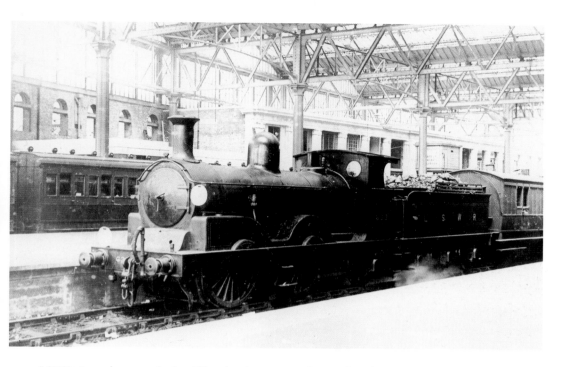

LSWR 633, photographed at Waterloo in 1920 on the north side of the station with the wall in the background. This is one of ninety 0-4-2 A12 class engines designed by William Adams. Fifty were built at Nine Elms and the remainder, including 633, by Neilson & Co. in Glasgow. None has been preserved. *Below*, South West Trains EMU 5916 at Platform 17.

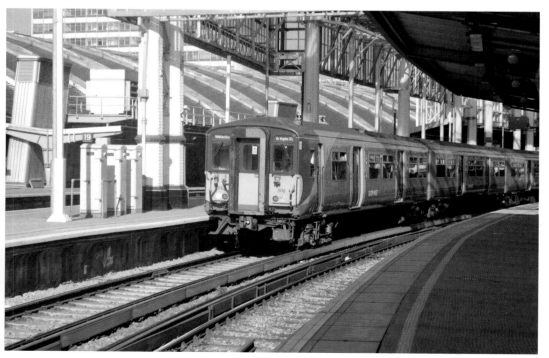

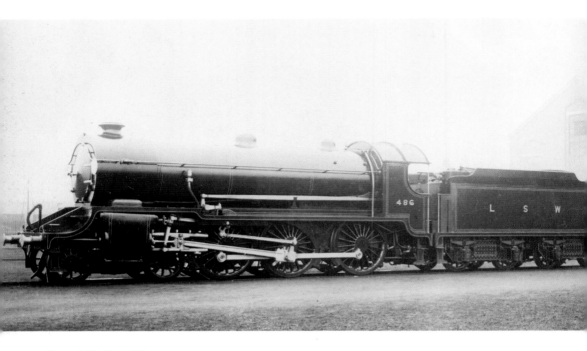

From LSWR to SR

No. 486 is an LSWR H15 class, 4-6-0, designed by Robert Urie for mixed traffic duties. It was built at Eastleigh in 1914, and in total twenty-six of this class were produced between 1914 and 1925, the later ones overlapping into the SR's years. *Below*, No. 468 at Waterloo in Southern Railway colours. The D15 class 4-4-0 was the last design produced by Drummond for the LSWR and only ten were built between 1912 and 1913 at the Eastleigh Works. The D15s were popular among their drivers and proved very successful on the express services to Bournemouth and Portsmouth.

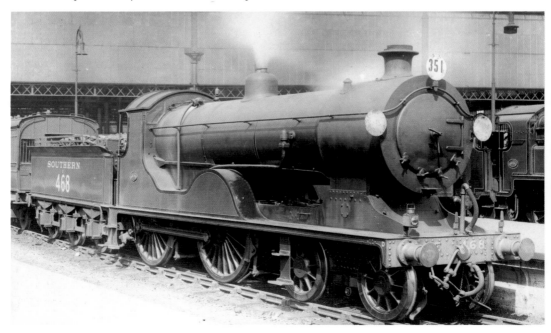

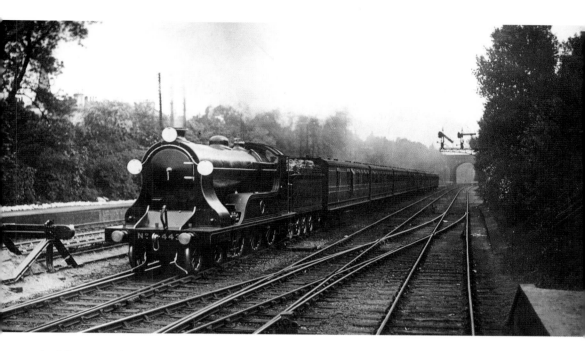

An LSWR T14 class 4-6-0 hauling an express train to Bournemouth. No. 443 was built at Eastleigh Works in 1911. Under the Southern Railway it was rebuilt in 1931 and withdrawn by British Railways in 1949. The white discs are headsignals, or headcodes, arranged in position to denote the class of train and route. Discs were used during daylight hours and lamps at night. This LSWR coach, *below*, is a tri-composite brake built at Eastleigh in 1903. It is displayed at the NRM in LSWR livery although the original 847 number has been replaced by SR's 6474.

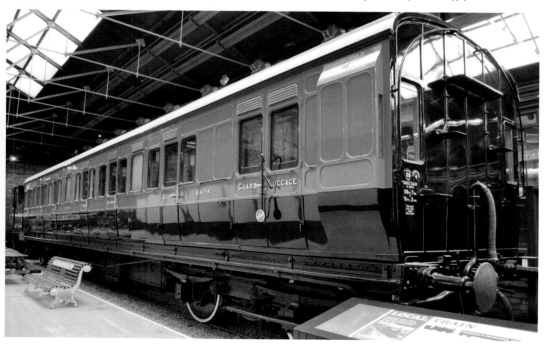

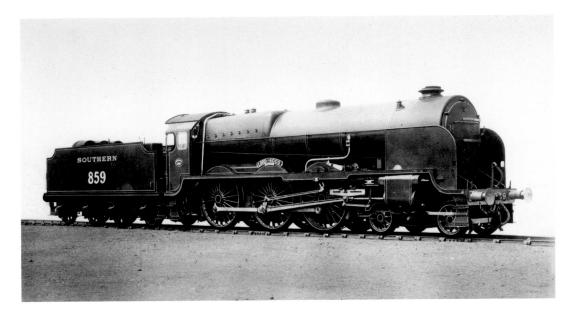

Southern Railway's Lord Nelson class

Designed by Richard Maunsell, the Lord Nelson class four-cylinder 4-6-0 engines were used for boat trains and passenger express services. Sixteen were built at the Eastleigh Works. They were named after famous admirals. No. 859, *Lord Hood*, shown above, was built in 1929 and withdrawn by BR in 1961. No. 852, renumbered as 30852, Walter *Raleigh*, was built in 1928 and withdrawn in 1962. Only one of the Lord Nelson class has been preserved.

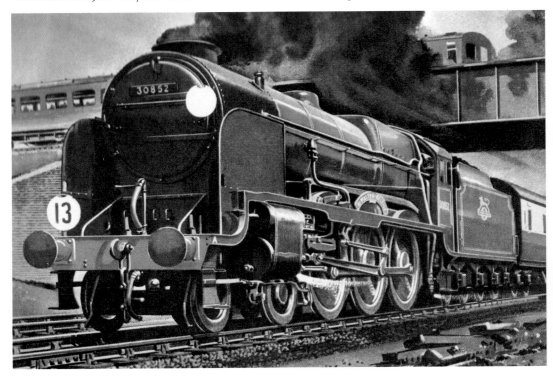

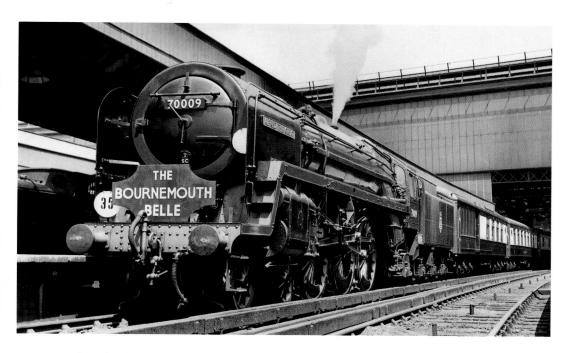

BR Britannia Class

70009, *Alfred the Great*, photographed at Waterloo at the head of the Bournemouth Belle in 1951, the year it was built at Crewe Works. The BR standard class 7, also known as Britannia class, were designed by Robert Ruddles for mixed traffic duties. *Alfred* was withdrawn in 1967. 700013 *Oliver Cromwell* is one of only two Britannia class to have been preserved. (*Ben Salter*)

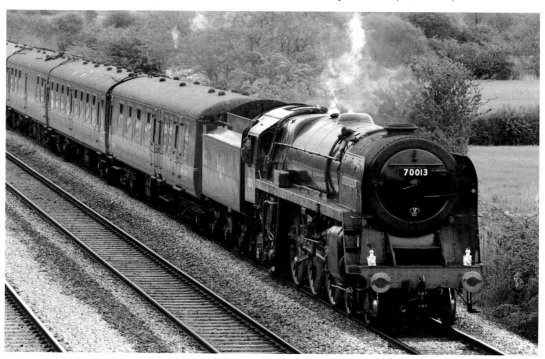

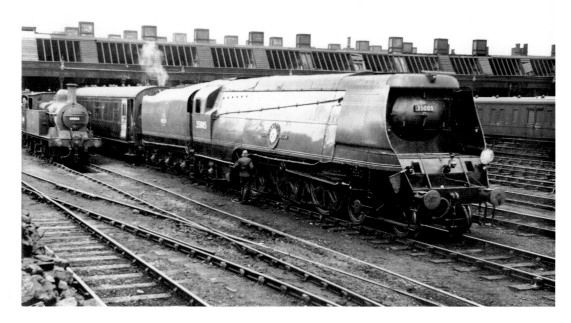

Bulleid Pacifics

35005, *Canadian Pacific*, a 4-6-2 of the Merchant Navy class designed by Oliver Bulleid and known as Bulleid Pacifics. It was built at Eastleigh in 1941, withdrawn in 1965, and is now with the Mid-Hants Railway. Although similar in appearance, the Battle of Britain class were slightly smaller and known as Light Pacifics. 345051 was built in 1946, named *Winston Churchill* in 1947, and used to haul the former prime minister's funeral train from Waterloo in 1965.

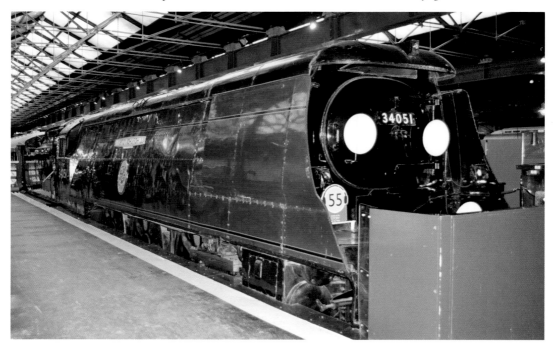

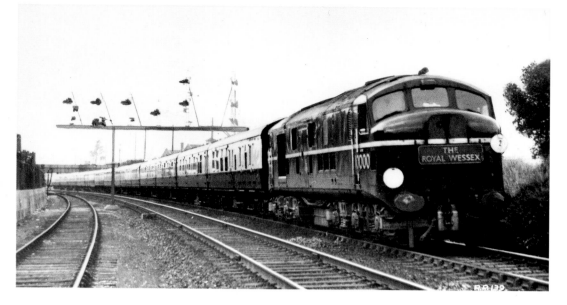

Diesel-Electric Days

The BR class D16/1 were the first mainline diesels in the UK. 10000 was built at Derby in 1947 and, along with 10001, transferred to the Southern Region from 1953 until 1955. The Royal Wessex was a limited stop service to Bournemouth Central, inaugurated in 1951 and named to mark the Festival of Britain. *Below*, No. 33118, a BR class 33/1, at Waterloo. Also known as the BRCW class or as Cromptons, they were built for the Southern Region between 1960 and 1962. (*Barry Lewis*)

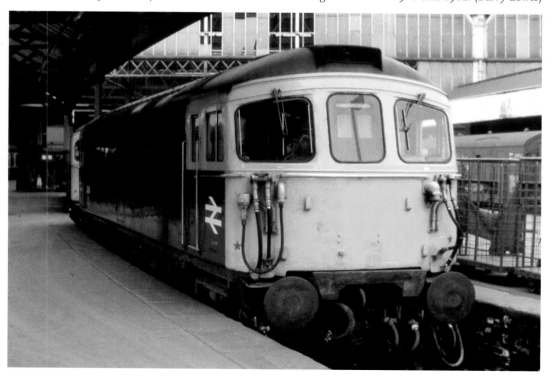

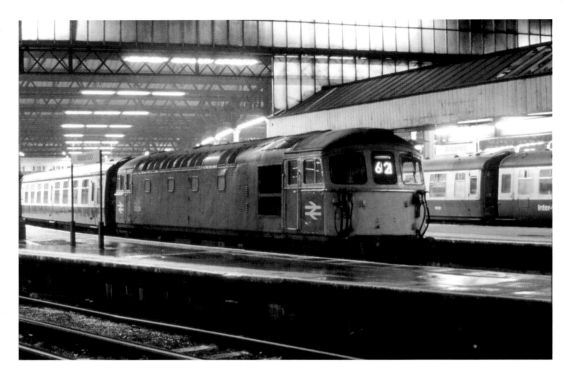

No. 33115, a Type 3 class 33/1, at Waterloo with the night train service to Exeter St David. (*Barry Lewis*) *Below*, 444013 is a BR class 444 Desiro EMU built in Austria by Siemens AG for South West Trains' long-distance fleet. These are made up of five coaches with two outer driving motors, two intermediate trailers and a central buffet. It is waiting on Platform 15, February 2013.

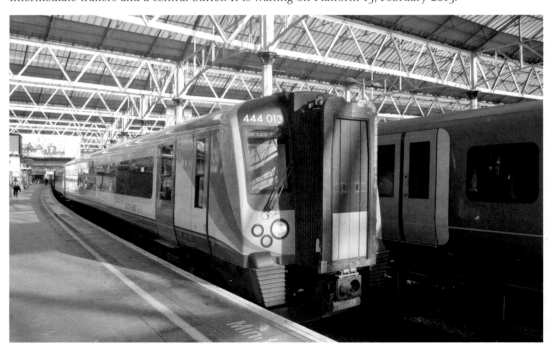

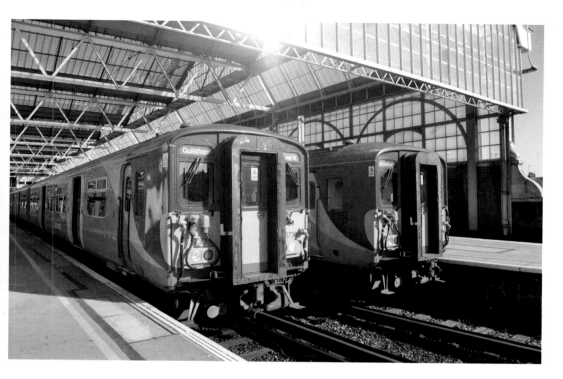

A pair of BR class 455s, basking in the sunshine on Platforms 3 and 2 with Epsom Guildford trains. Designed for suburban services, the class 455 EMU draws power from a 750 volt DC third rail. They were built by BREL at the York Works in the 1980s. *Below*, 5706 on Platform 4 going to Shepperton via Kingston.

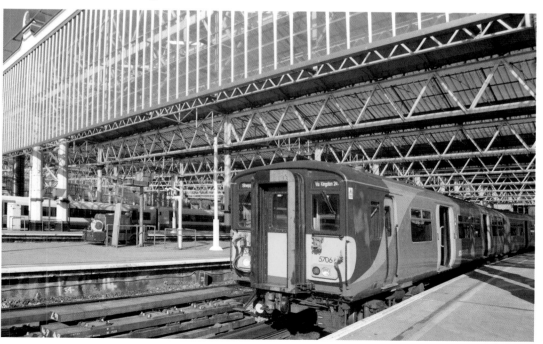

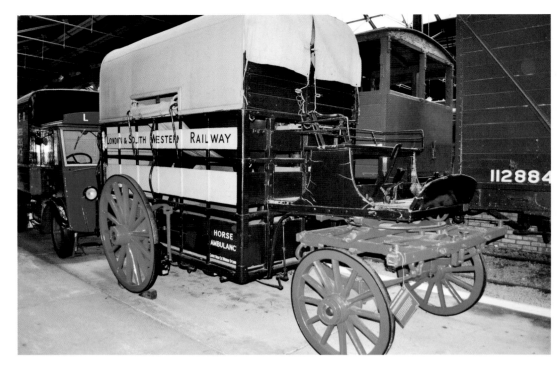

Railway Vehicles

Two examples of LSWR horse-drawn vehicles: *Above*, a horse ambulance displayed at the NRM. *Below*, an LSWR delivery van has been overturned by a hostile mob during the 'great London strike', 10 August 1911. The crates are labelled 'Kevils Hams'. (*CMcC*)

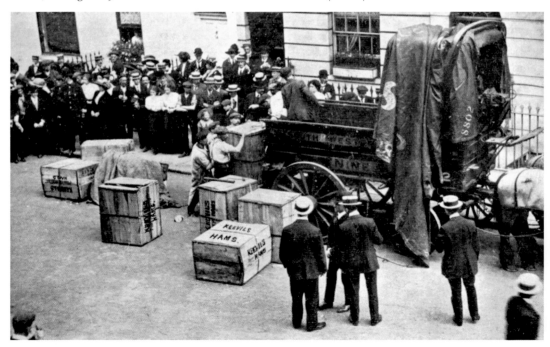

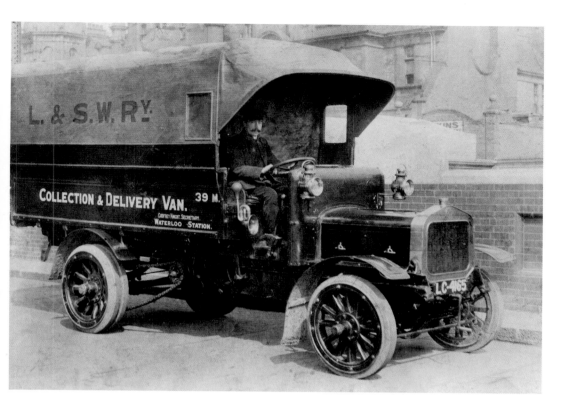

A superb photograph of an early motorised LSWR Collection and Delivery Van. (*CMcC*) Nowadays, the only vehicle you are likely to see on Waterloo's platforms is one of these Network Rail electrics, used either for passenger assistance or servicing and supplying the trains.

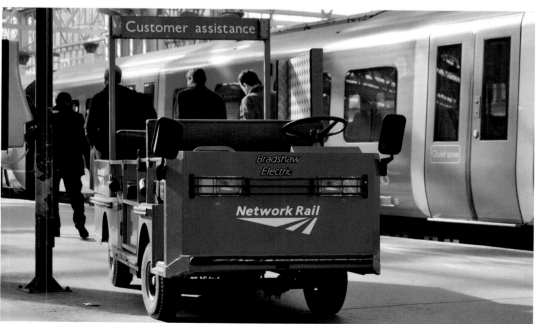

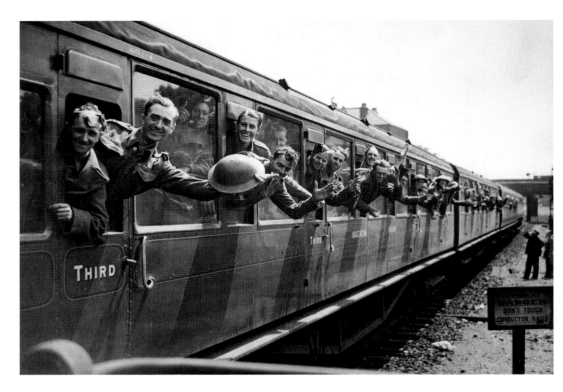

Despite their ordeal at Dunkirk, some very happy members of the British Expeditionary Force wave to the press photographer from an SR train on their way to London. Inevitably, Waterloo was targeted by the Luftwaffe's bombers during the Blitz. Note the hit on the Necropolis Station.

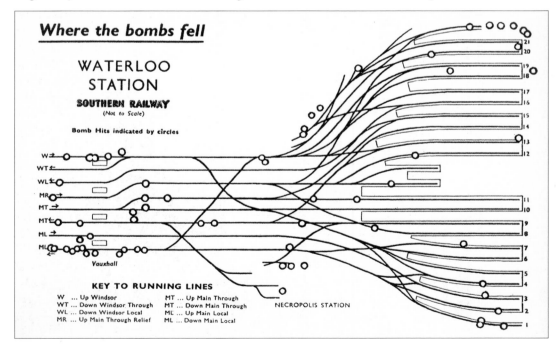

Where the bombs fell

WATERLOO STATION
SOUTHERN RAILWAY
(Not to Scale)

Bomb Hits indicated by circles

Vauxhall

NECROPOLIS STATION

KEY TO RUNNING LINES

W ... Up Windsor	MT ... Up Main Through
WT ... Down Windsor Through	MT ... Down Main Through
WL ... Down Windsor Local	ML ... Up Main Local
MR ... Up Main Through Relief	ML ... Down Main Local

64

Waterloo at War

Given Waterloo's connections to Southampton and the dockyards at Portsmouth, it has played an important role in a number of conflicts. The first came with the outbreak of the South African or Boer War, in 1899, when the old station became the major 'entraining' point for the infantry, while Nine Elms was used for the cavalry.

There were similar scenes during the First World War, 1914–1918, not only with troops heading out to fight in the trenches, but also those returning, either on leave or in ambulance trains. In January 1916 a free buffet for servicemen operated in the subway and on one occasion King George V, accompanied by the Queen and Princess Mary, paid them a visit. There was further excitement in 1917 when thousands of people crammed into the station to cheer the arrival of special trains bringing American troops. As previously mentioned, the Victory Arch commemorates the railway staff who lost their lives fighting for their country. Waterloo was also subject to a solitary air raid in September 1917, when bombs fell on the north side of the station – a precursor of things to come.

Following the outbreak of the Second World War in the autumn of 1939, thousands of evacuees, mostly young school children, poured through London's termini to get away from the threat of air raids. This was not the only exodus handled by the railways. At the end of May 1940 the Southern Railway (SR) sent its cross-Channel boats to join the fleet of assorted vessels which was hastily mustered to rescue troops stranded in France. Codenamed Dynamo, this operation recovered more than 300,000 men in what became known as the 'miracle of Dunkirk', but in the process the SR lost five of its boats. Back in the south of England, all civilian rail services were cancelled to free the lines for the movement of the troop trains. The lion's share of these, 327, departed from Dover, and to meet the sudden demand the 'Big Four' railway companies formed a pool of coaches.

The anticipated air raids on London didn't materialise during the initial 'phoney war' and it wasn't until September 1940 that the first bombs fell on Waterloo. By the end of the war fifty enemy bombs had found their mark, and a diagram in the SR's publication *War on the Line* shows where these fell. Inevitably, there were some interruptions to the station's operation – the worst being for twelve days after a particularly heavy raid in September 1940. In 1941 the old general offices on the corner of York Road were destroyed, as was the spur to the Necropolis Station – *see page 51*. Air raid shelters were created under Waterloo's arches to accommodate up to 6,500 people, and these also provided temporary homes for many of Lambeth's bombed-out residents.

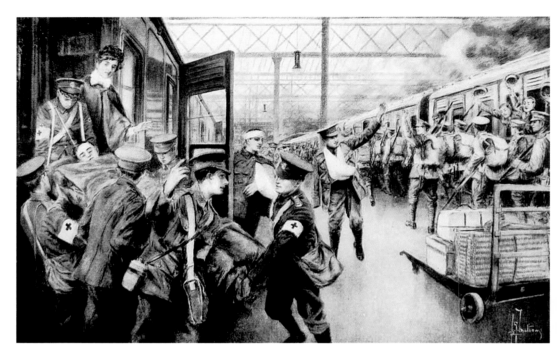

First World War Departures and Arrivals
A patriotic portrayal of the scene at Waterloo as a departing contingent of troops cheer on their wounded colleagues returning from the trenches. *Below*, the reality as a newly arrived hospital train is unloaded. (*CMcC*)

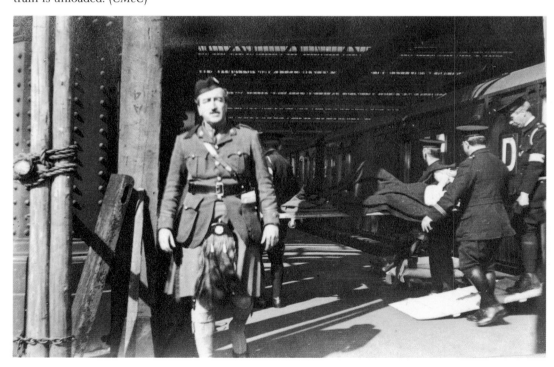

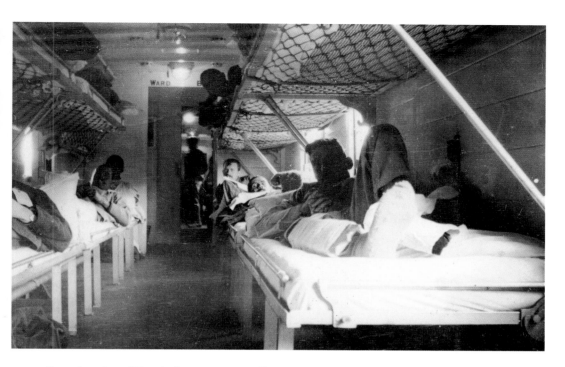

Above, interior of Hospital Train No. 11, pulling into a station at Bournemouth, where the men are being sent for treatment and recovery. (*CMcC*) *Below*, located within the Victory Arch entrance, the Roll of Honour listing LSWR staff members who died in the 1914–1918 conflict.

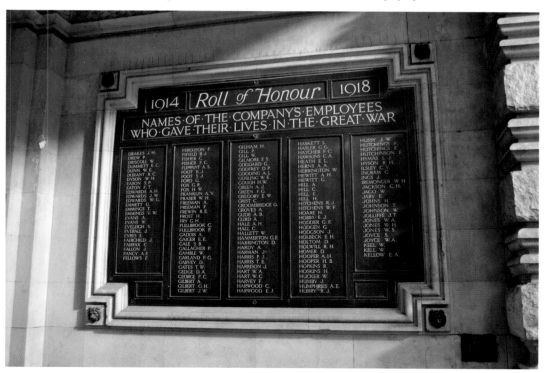

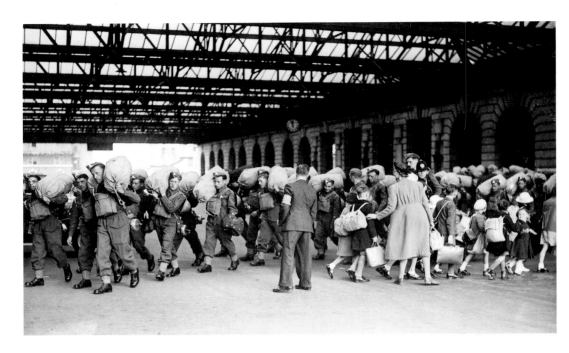

Second World War Travellers

Underneath the main entrance canopy at Waterloo, these newly arrived and fresh-faced troops pass a group of school children going into the station. In the autumn of 1939 the fear of imminent air raids upon the capital led to an unprecedented exodus of the young and vulnerable. Thousands of road vehicles were mustered to take 345,812 passengers to the various stations in an operation completed in four days.

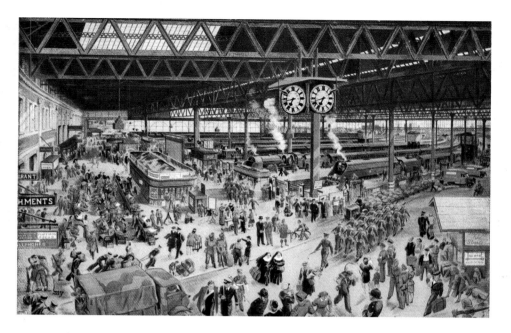

In 1948 the Southern Railway celebrated the station's centenary with a pair of posters featuring illustrations of 'War and Peace' by artist Helen McKie. In addition to the predominance of khaki and navy uniforms, note the blackout on the glass roof and the cover on top of the station clock in the wartime version.

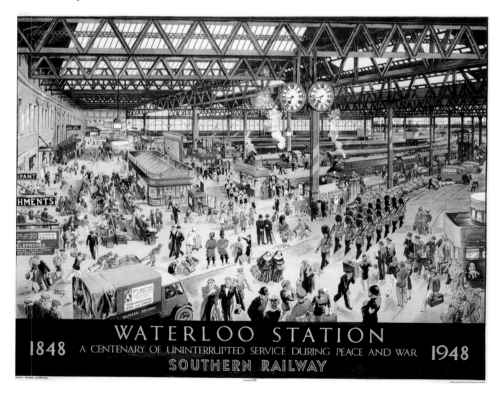

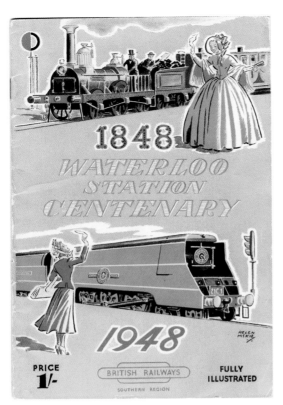

Post-war

Cover of the booklet commemorating Waterloo's centenary in 1948. This happened to be the year which saw the nationalisation of Britain's railways, when the station became the headquarters of BR's Southern Region. *Below*, on 30 January 1965 a sombre crowd gathered at Waterloo to witness the arrival of Winston Churchill's funeral cortege. The coffin was then taken by special train to Hanborough in Oxfordshire. Apart from its historical significance, this photograph shows the gap left where the general offices on the corner of York Road were destroyed by enemy action. Note the uncluttered approach with gates in place, and also the Goding's lion on his pedestal.

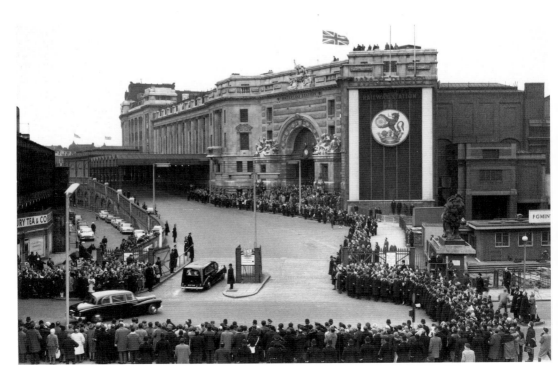

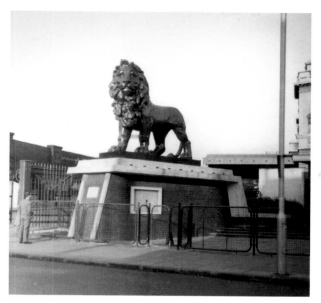

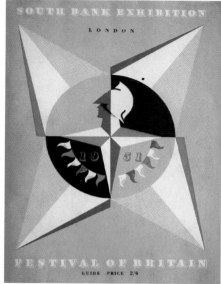

The Coade Stone Lion

After Goding's Red Lion Brewery was badly damaged in the Blitz the lion, which had stood on the parapet, was moved to a pedestal on the corner of York Road. Still painted red, it pointed visitors in the direction of the 1951 Festival of Britain site. Then, in 1966, it was relocated to the South Bank side of Westminster Bridge. Stripped of its red coat, it has been laid bare in what appears to be a stone finish, but the 13-ton beast is actually made of an artificial material known as Coade Stone.

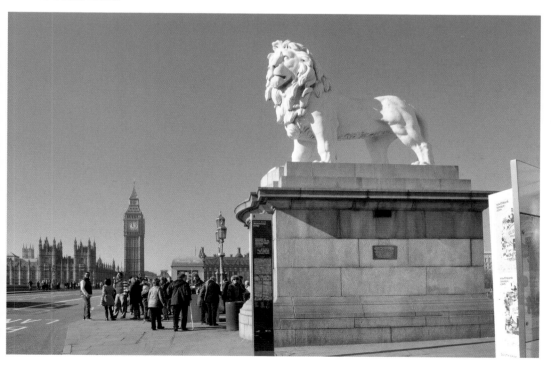

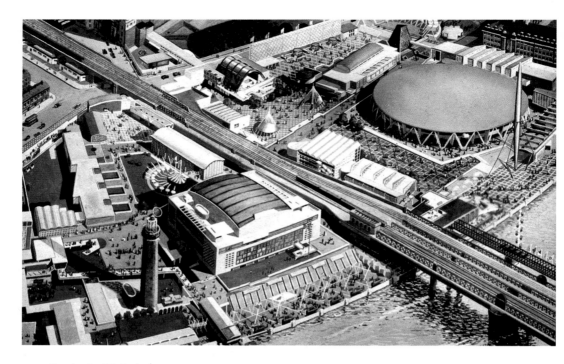

1951 Festival of Britain

Heralded as a 'tonic to the nation', the festival was a post-war celebration of the best in British achievements from industry, science, architecture and the arts. Its focal point was a bomb site on the South Bank dissected by the railway to Charing Cross. The iconic landmarks included the saucer-dome, Skylon needle and the Festival Hall. Visitors arriving via Waterloo crossed York Road on a raised walkway to an entrance crowned by high parabolic arches of laminated timber.

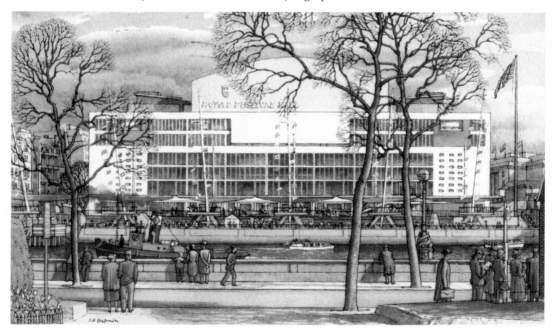

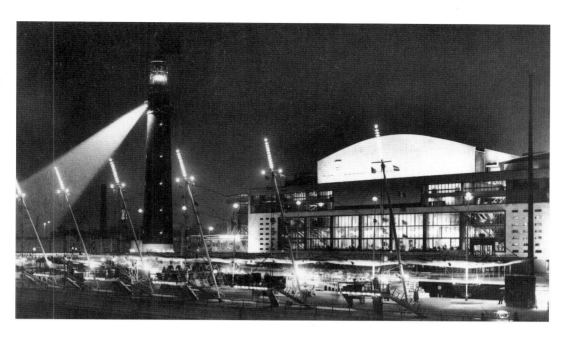

The South Bank

Two views of the Festival of Britain site seen from the Hungerford or Charing Cross Bridge (during the festival, a temporary Bailey bridge was constructed beside the railway bridge and the modern cable-stayed Golden Jubilee footbridges were completed in 2002). *Above*, in 1951, the lighthouse was a former shot tower, now gone. The only surviving feature from the festival, apart from the public spaces, is the Royal Festival Hall which has undergone some remodelling to its front. The National Theatre occupies the site to the left.

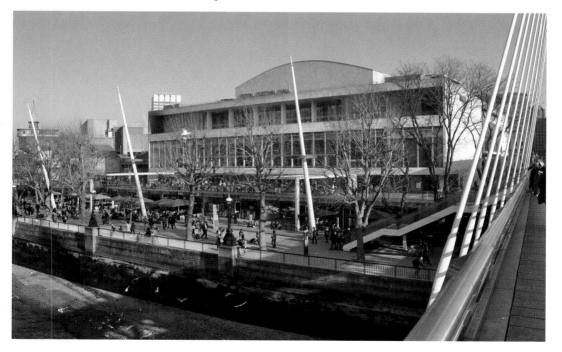

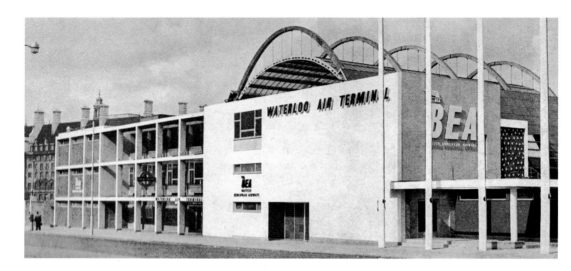

BEA Waterloo Air Terminal

In the days before direct rail links went to Heathrow, a helicopter air shuttle was established, going from the former Festival of Britain site. The British European Airways Waterloo Air Terminal opened on 25 July 1955, occupying the disused north entrance buildings on York Road. Two Westland WS-55 Whirlwind I helicopters were used and had the registration numbers G-ANFH and G-ANUK. The shuttle service carried 3,822 passengers, but was closed down after ten months, apparently because too many people were using it for cheap sight-seeing tours. At one time there was talk of creating a landing pad on the station roof, but this came to nothing and a coach shuttle service ran for several years until the Festival site was cleared for redevelopment and the Shell Complex building. The heli-pad at Battersea opened in 1959.

Waterloo International

During the twentieth century Waterloo became the arrival and departure point for special boat trains to Southampton. The international clientèle arriving at Platform 11 included the rich and a steady stream of celebrities, plus important political figures of the day. The LSWR owned Southampton Docks and from 1904 express boat train services were extended temporarily to include Plymouth (Devonport) to serve vessels of the American Line (the GWR took over the Plymouth boat train services in 1910). The famous post-war 'Ocean Liner Specials' were branded with names such as The Cunarder, Statesman, Union Castle Express and The Holland American. The Cunarder was a Pullman train connecting with Cunard's Queens, RMS *Queen Mary* and *Queen Elizabeth*. Inaugurated in July 1952, it continued until the late 1960s, but by then transatlantic ocean liners were losing out to the airlines. For a while an influx of immigrant ships brought new travellers to London via Waterloo. More recently, a smaller number of specials connected with the newer ships, the *QE2* and *Queen Mary 2*, up until October 2007.

International connections were maintained from November 1994, when Waterloo acted as the temporary terminus for the Eurostar service via the Channel Tunnel to Paris and Brussels. A new £120 million facility was created by hiving off Platform 20 and adding four additional platforms under a curved roof of steel and glass. The final Eurostar train departed from Waterloo International on 13 November 2007, after which all services were transferred to St Pancras. Apart from a stint in 2010 as the venue for a theatrical production of *The Railway Children*, the Eurostar facilities remain unused and their future role is uncertain. Waterloo is earmarked as the London terminus for the proposed Heathrow Airtrack service, with a spur running from the mainline to the airport.

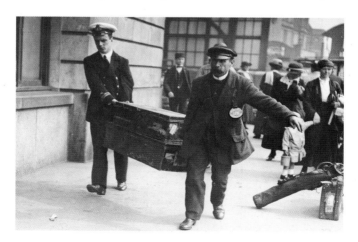

A naval officer is assisted by a taxi driver to take his trunk to the boat train during the 1911 strike.

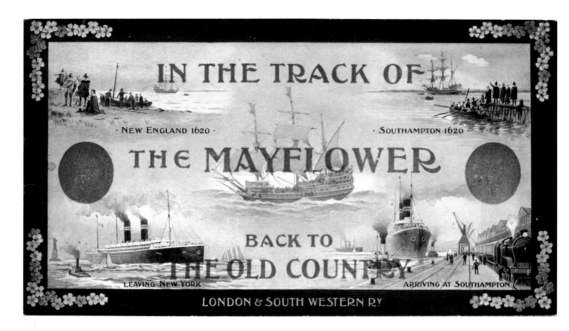

IN THE TRACK OF

· NEW ENGLAND 1620 · · SOUTHAMPTON 1620 ·

THE MAYFLOWER

BACK TO
THE OLD COUNTRY

LEAVING NEW YORK ARRIVING AT SOUTHAMPTON

LONDON & SOUTH WESTERN RY

By Boat Train

An LSWR brochure from 1911 promoting the transatlantic connection. The railway company owned Southampton Docks and special boat trains took passengers from Waterloo direct to the docks. *Below left*, young sailors from HMS *Impregnable* catch the boat train in this 1907 illustration published in the *Daily Graphic*. From April 1904 until 1910 the LSWR also ran express trains to Plymouth, Devonport, to serve the vessels of the American Line. *Right*, Waterloo was the arrival point in London for countless dignitaries and political figures.

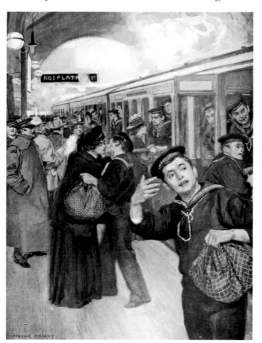

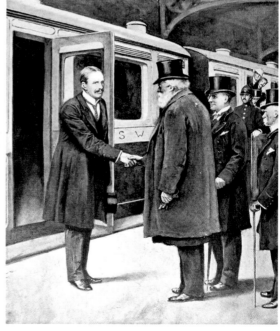

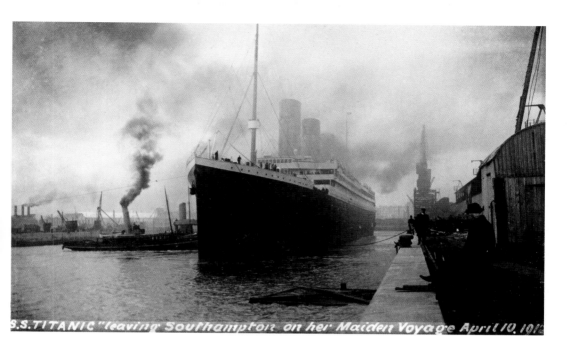

S.S.TITANIC "leaving Southampton on her Maiden Voyage April 10, 1912"

On the morning of 10 April 1912 two special boat trains left Waterloo to take passengers to the SS *Titanic* at Southampton Docks, one at 7.30 a.m. for the second and third class passengers, plus the valets and maids of the wealthier passengers, and another at 9.45 for the first class passengers. *Below left*, Boat Train Departure information for 13 June 1957, including several going from Platform 11 for the *Queen Mary*, and, *right*, menu card for the 1936 boat train for the maiden voyage of the *Queen Mary*. (*CMcC*)

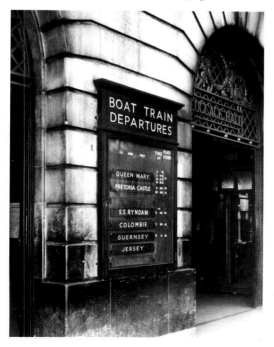

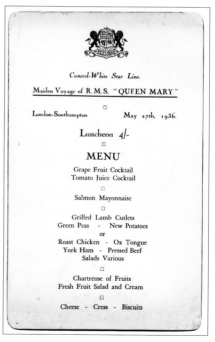

Cunard-White Star Line.

Maiden Voyage of R.M.S. "QUEEN MARY"

London-Southampton May 27th, 1936.

Luncheon 4/-

MENU

Grape Fruit Cocktail
Tomato Juice Cocktail

Salmon Mayonnaise

Grilled Lamb Cutlets
Green Peas - New Potatoes
or
Roast Chicken - Ox Tongue
York Ham - Pressed Beef
Salads Various

Chartreuse of Fruits
Fresh Fruit Salad and Cream

Cheese - Cress - Biscuits

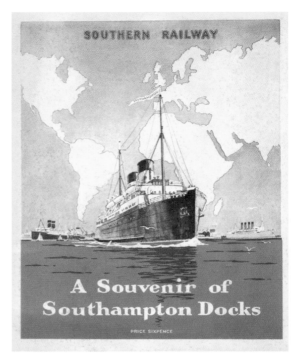

'Gateway to the Empire'

When the LSWR purchased the Southampton Dock Company in 1892, it invested heavily in new facilities to attract more trade. By 1908 there were twenty-one shipping companies sailing from there, including the White Star Line which owned the *Titanic*. By the 1930s the dock was handling 46 per cent of all ocean-going passenger traffic, with 2,500 passenger trains per year. The Southern Railway organised special excursions and tours of the docks and these illustrations come from the official guide book. *Below*, the Ocean Dock is in the foreground.

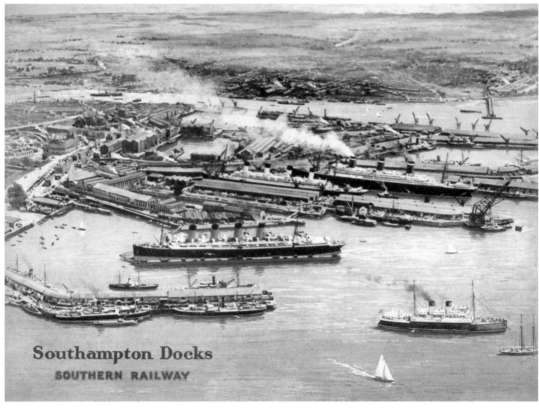

Southampton Docks
SOUTHERN RAILWAY

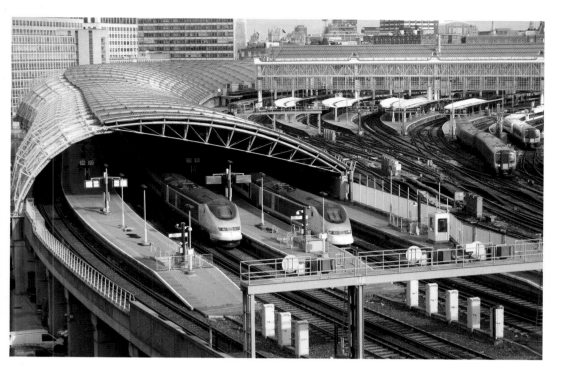

By Train to the Continent – Eurostar

In 1992 the remaining parts of the old North Station, including sidings on that side and the 1936 signal box, were swept away for the temporary Eurostar terminal. This operated from 1994 until 2007, when the facilities at St Pancras were completed. (*Timothy Saunders*) Without a rail connection, the lift was the only access down to the WCR. (*Kevin Lane*)

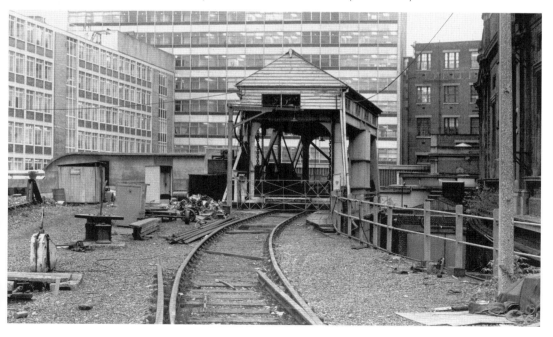

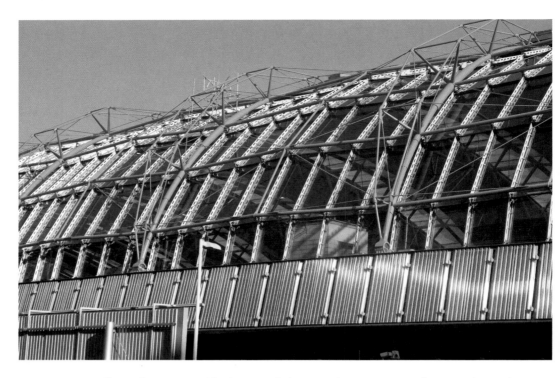

Costing £120 million, the most visible feature of the Waterloo International terminal was the sinuous 1,312-foot (400 metres) roof covering the five Eurostar platforms. The exoskeleton is a glass and steel prismatic vault of thirty-seven arches supported on concrete columns rising up from the car park level. Photographed in 2013, it stood empty and unused.

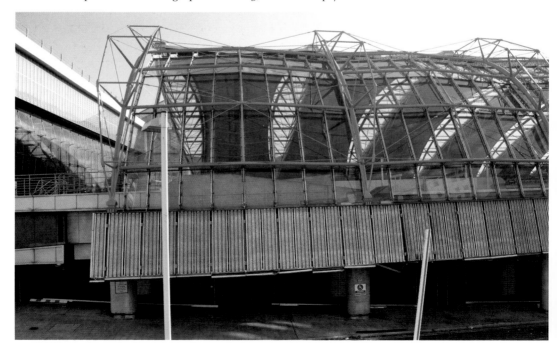

Waterloo Connections

Waterloo East

The South Eastern Railway opened a smaller station to the east of the main one in 1869, on the line from Charing Cross going over the river and eastwards through London Bridge to Kent. It was known as Waterloo Junction until 1935, when the Southern Railway changed it to Waterloo Eastern, shortened to Waterloo East in 1977.

Formerly, the line was connected to Waterloo via a single track passing over Waterloo Road and terminating on the main concourse itself – *see page 8*. The bridge is still there but the rail connection has gone and a new higher tubular footbridge connects the two stations, emerging on the balcony level at Waterloo (from its windows you can look across the Hungerford Bridge and straight down the throat of Charing Cross). At street level there is a secondary entrance on Sandell Street and on the eastern end of the station a pedestrian connection leads to Southwark station on the Jubilee line. Waterloo East has no station building or ticket office – the mainline station fulfilling this purpose – but it is more than just a satellite with its four platforms, labelled A to D to avoid possible confusion with the main station.

Underground

Located to the south of the river, Waterloo was a relative late-comer to the underground network, and it remains one of only two termini not connected to the Circle Line (the other being London Bridge). The first underground station at Waterloo served the Waterloo & City Railway (WCR), which opened in July 1898. Known as the 'Drain', this 1.47 mile line was built independently of the main underground system and had only two stations, Waterloo and Bank at the other end. Originally it was operated by the LSWR, later by the mainline railway companies, only passing from British Rail ownership to London Transport as recently as 1994. There is still no rail connection with the rest of the system and until the construction of the Eurostar terminal in 1994, access to the surface was provided by means of an Armstrong hydraulic platform lift on the western side of the main station.

The Baker Street & Waterloo Railway (BSWR), the two names later amalgamated as 'Bakerloo', opened in March 1906. In 1926 a new station was opened on the extension of the Hampstead & Highgate line, the Charing Cross branch of the northern line from Embankment to Kennington. Far more recently, in September 1999, the Jubilee Line Extension reached Waterloo. Although the tally of underground lines at Waterloo only comes to three – four if you include the WCR – it is, nonetheless, the busiest station on the underground network.

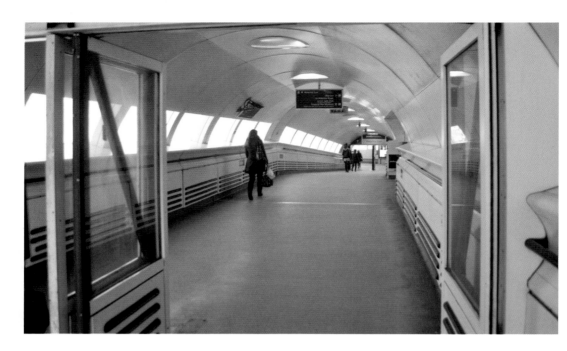

Waterloo East

The high-level walkway to Waterloo East. This extends from the balcony level of Waterloo Station – *see page 8*. To avoid confusion with the mainline station, the four platforms are designated A to D. *Below*, a Southeastern class 465 EMU, No. 465928, arrives from London Bridge on its way to Charing Cross, with the newly completed Shard visible in the background.

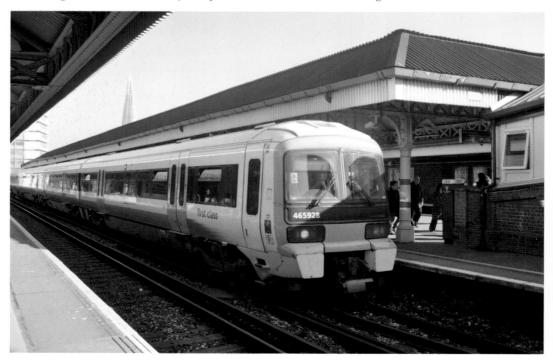

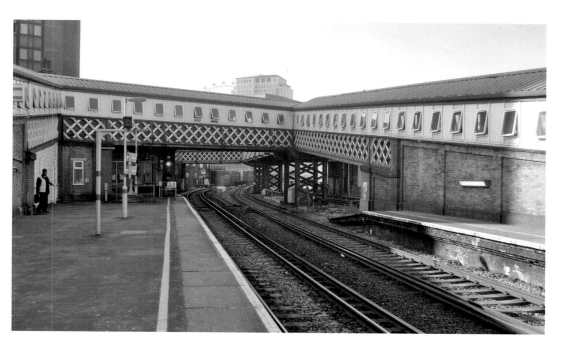

Waterloo East was originally opened by the South Eastern Railway as Waterloo Junction in 1869. It was renamed as Waterloo Eastern by the Southern Railway, only shortened to Waterloo East in 1977. Looking north-west, the covered walkways lead to Waterloo Station and connect the four platforms, with the track passing over Waterloo Road on its way to the Hungerford Bridge and Charing Cross. *Below*, a fine piece of original cast iron detailing on Platform C.

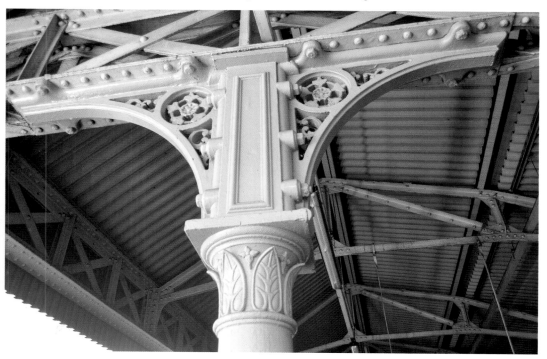

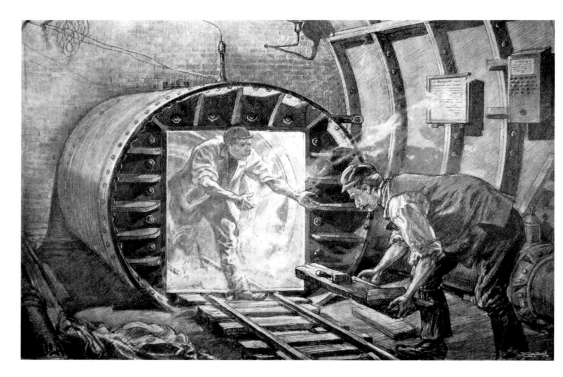

Down the 'Drain'

An illustration from an 1895 edition of *The Graphic* showing tunnel workers passing items through an airlock to the main works, which were pressurised to keep the water out. The Waterloo & City Railway, unofficially known as the 'Drain', opened on 11 July 1898 to connect Waterloo with Bank Station, *shown below*. Independent of the London Underground network, it ran for just 1.47 miles with a journey time of barely four minutes from end to end.

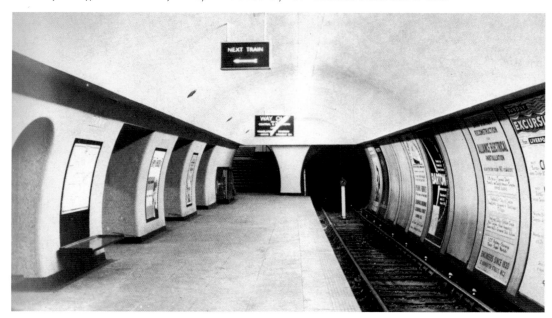

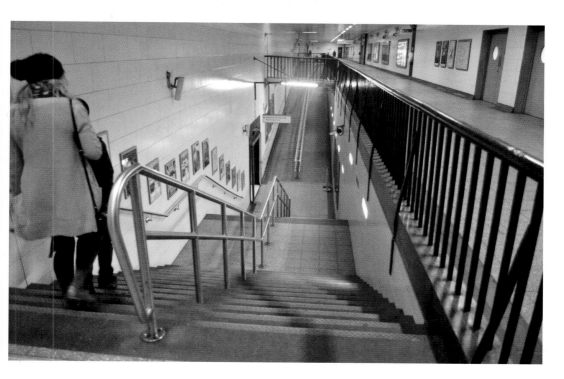

Going down the Drain beneath Waterloo. It has been smartened up since John Betjeman described it as 'a bleak, white tiled station' with the 'pleasant smell of a changing room after games'. Note the platform information board stating that 'All trains go to Bank'. Where else?

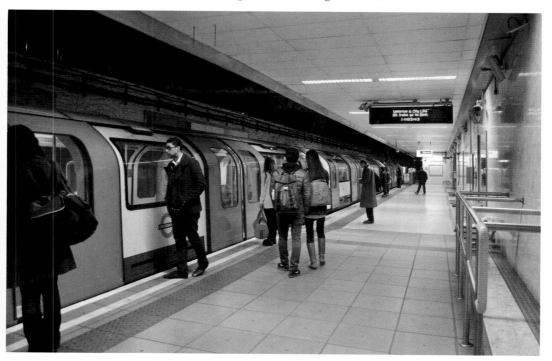

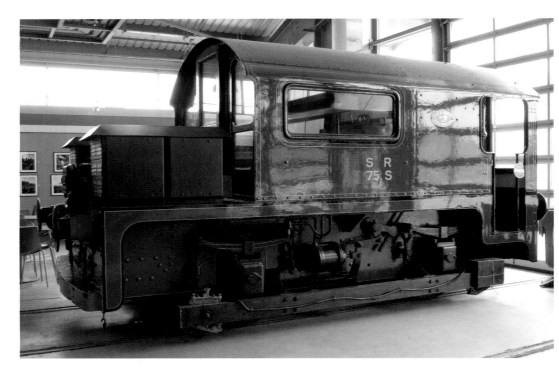

Preserved WCR electric battery locomotive No. D75S at the NRM's Shildon facility in County Durham. Built by Siemens in 1898, it was used to take coal from the hoist to the generator. (*Ultra7*) The WCR is the only line in London to run underground for its entire length and in addition to the hoist spur it had sidings and a depot beneath Waterloo.

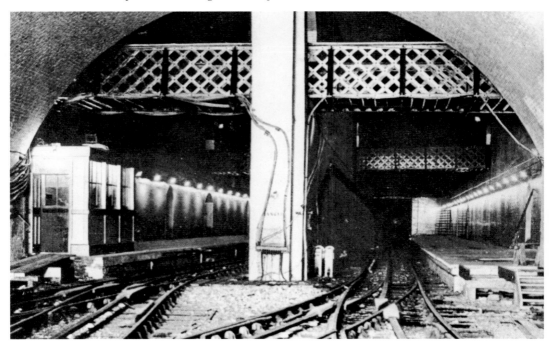

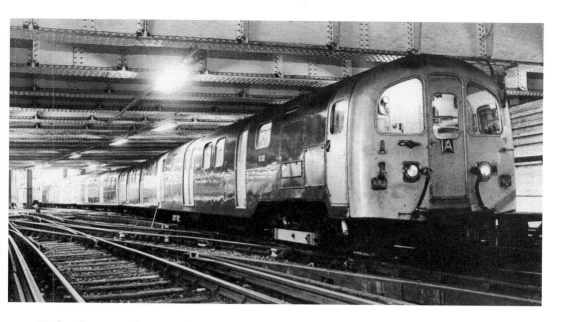

Under the nationalisation of the railways in 1948, the WCR became part of British Railways Southern Region and this official photograph from 1980 shows a five-car train of 1940s stock in the underground sidings. The old stock was replaced in 1993 and by the time of the 2006 refurbishment it had to be lifted off the line by crane as the Armstrong hydraulic hoist had been demolished to make way for the Eurostar terminal. (*Owen Dunn*)

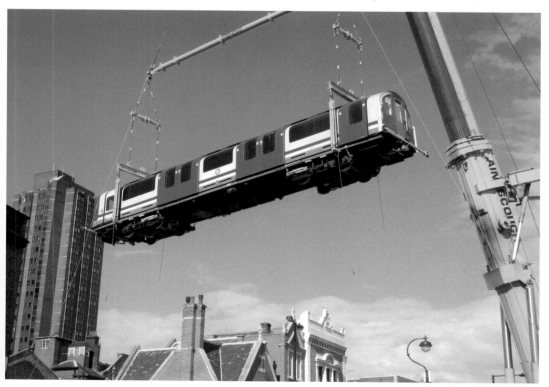

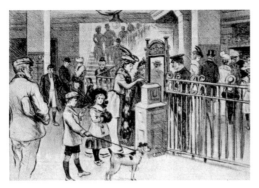

The Bakerloo Line

The first part of the Underground network to reach Waterloo was the Baker Street & Waterloo Railway, which opened on 10 March 1906 and served eight stations between Baker Street and Kennington (the name Bakerloo was first coined by the *Evening Standard* and soon stuck). The illustrations from *The Graphic*, *above*, show passengers at Baker Street and Trafalgar Square using the railway in its first week of opening. As rush hour traffic increased, the traditional lifts on the underground were supplemented by 'moving staircases' or escalators, the first being installed at Earl's Court station in 1911. *Lower left*, the three-lane escalator at Waterloo; this arrangement allowed for the central one to be reversed during the rush hours. According to the *Telegraph Travel 150 Fascinating Tube Facts*, Waterloo now has more escalators than any other London station, twenty-three in all.

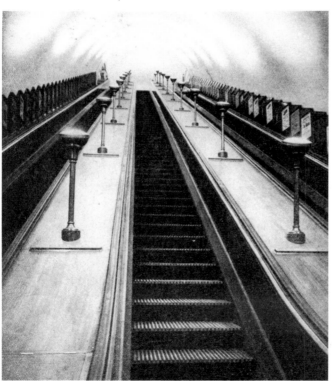

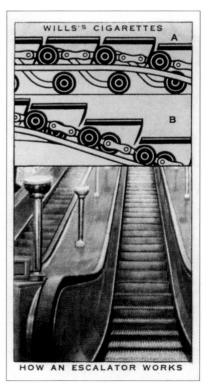

WILLS'S CIGARETTES

HOW AN ESCALATOR WORKS

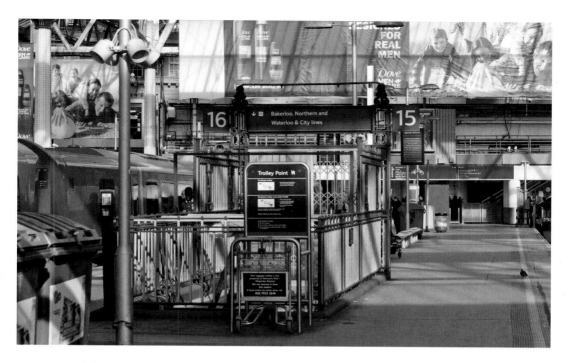

One of the old entrances going down from the main platforms to the subway leading to the Bakerloo, Northern and Waterloo & City lines. Apparently the term 'tube' was first used in 1890 as an obvious reference to the shape of the tunnels. *Below*, the curving northbound platform of the Bakerloo line at Waterloo. The floor tiles look like a piano.

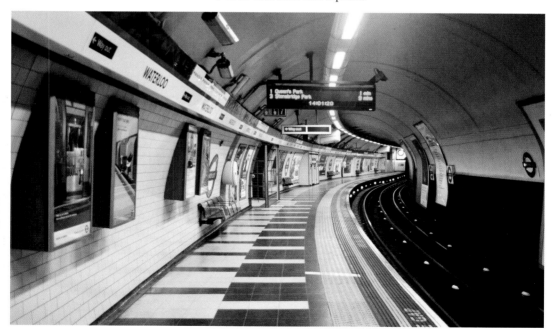

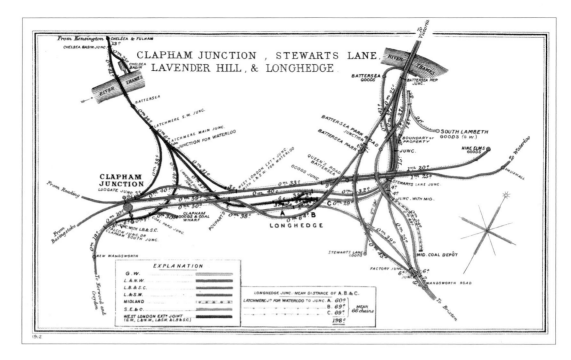

Rail Connections

LSWR era chart of the westward connections from Waterloo, shown on the right. Note the spur to Nine Elms Goods and as the blue line heads west through the tangle of Clapham Junction, it then splits for Reading or Basingstoke. *Below*, the Hungerford Bridge taking the SER line across the Thames to Charing Cross. You can see the piers for the suspension bridge which was originally designed by Brunel as a pedestrian crossing to the Hungerford Market on the north bank.

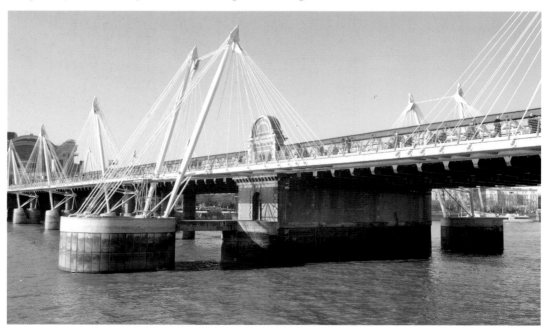

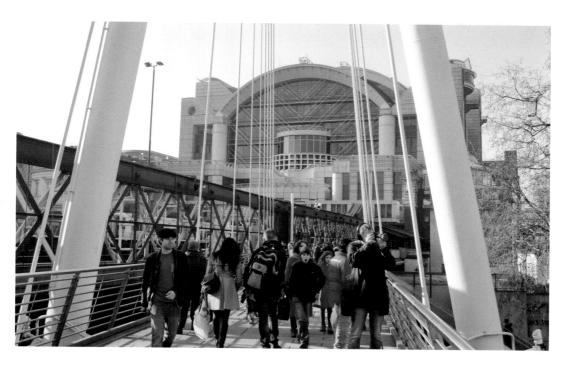

Charing Cross Station

Viewed from one of the two Golden Jubilee footbridges which run either side of the railway line. The upper structure of Brunel's suspension bridge was demolished in 1863 to make way for the railway bridge. *Below*, the old Charing Cross Station in the age of steam. Originally opened in 1864 by the South Eastern Railway, the station was massively restyled in the 1990s and covered by the Embankment Place development.

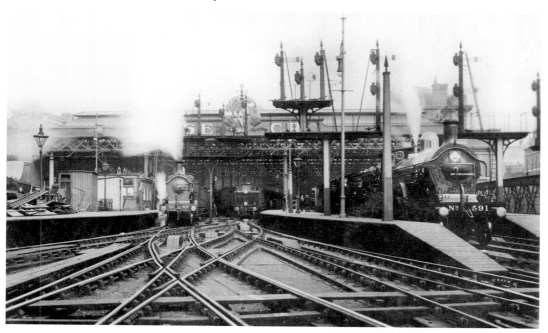

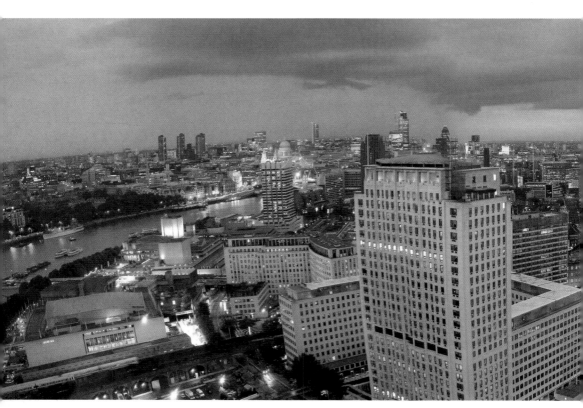

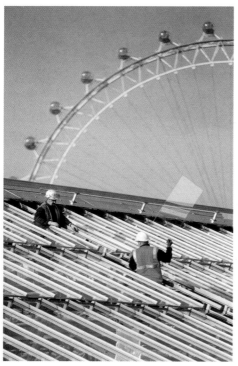

Waterloo Sunset

One of the most striking aspects of Waterloo for anyone visiting the station in recent years is the amount of light that now pours in through the crystal clear roof. *Above*, seen from the London Eye a panoramic view looking towards the station. (*Ilya Khuroshvili*) Designed by J. W. Jacomb-Hood and his successor A. W. Szlumper, the transverse ridge and furrow roof has an area of 2.4 acres and is said to be the largest station roof in Europe. However, by the end of the twentieth century the massive roof was suffering from neglect with countless make-do repairs carried out over the years. Thankfully the main structure was in good shape, but the glazing needed a total refurbishment and Network Rail launched a £41m programme which was carried out between 2001 and 2003. *Left*, replacing one of the 24,000 glazing panels. (*Network Rail*)

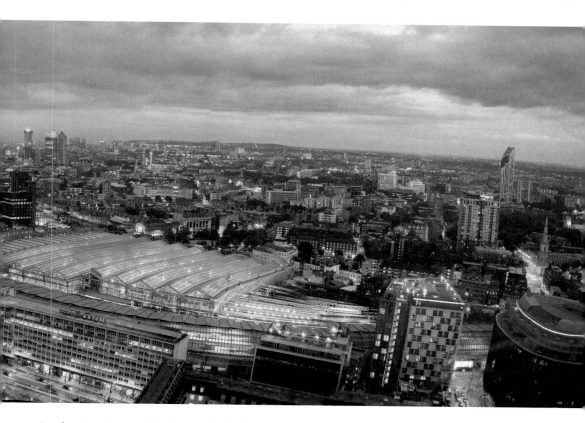

South West Trains BR class 458, No.8012, departing from Platform 18 with the roof of the Eurostar terminal behind, 2013. The 458s were built by Alstom, at Washwood Heath, between 1998 and 2002.

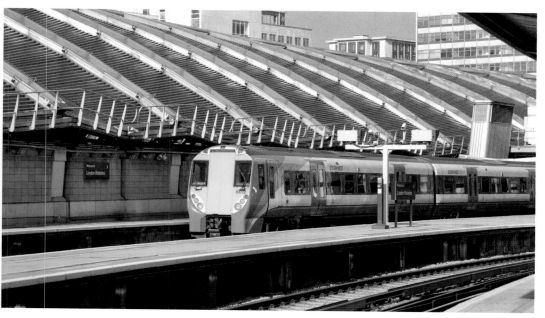

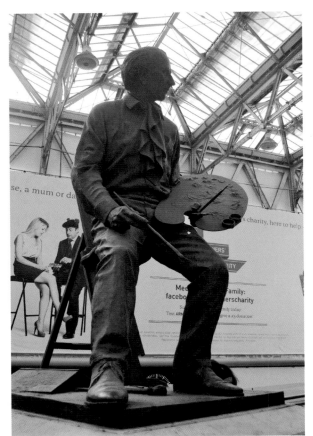

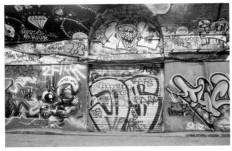

Art at Waterloo

St Pancras has John Betjeman, Paddington its bear, and at Waterloo the only public sculpture is of Terence Cuneo, the well known painter of railway subjects. But without any representation of his work most travellers barely give it a glance, especially as the concourse has become increasingly cluttered. Many people will identify more readily with the graffiti tunnel in Leake Street, *above*.

Below, an interesting illustration of Waterloo from an old children's book, *Off By Train*.

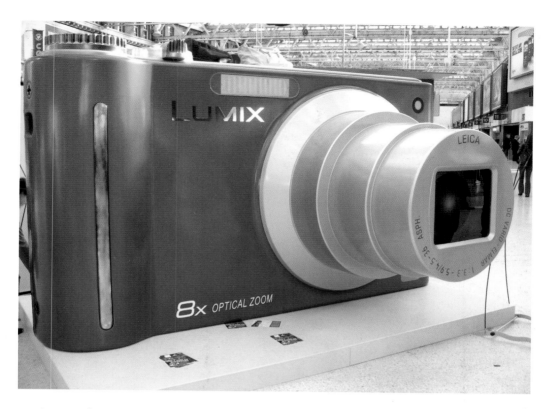

Art or advertising? The lines are sometimes blurred. This giant camera was snapped on Waterloo's concourse a few years ago. The camel is perched on a nearby rooftop and advertises a restaurant in Lower Marsh to the passing trains.

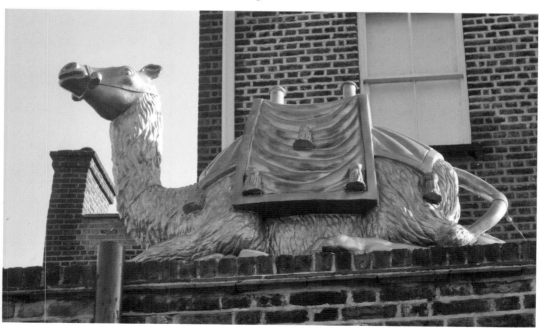

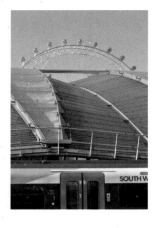
Train, Eurostar roof and the London Eye.

Further Reading

London Historic Railway Stations, by John Betjeman, John Murray, 1978.
London's Termini, by Alan A. Jackson, David & Charles, 1969.
Waterloo Station circa 1900, by Colin Chivers and Philip Wood, South Western Circle, 2006.
Waterloo Station Centenary, British Railways Southern Region, 1948.
War on the Line, Southern Railway, 1946.
This is Waterloo, by Colin J. Marsden, Ian Allan, 1981.
Terminus – the excellent 1961 film by John Schlesinger is available on DVD.

Online resources
Network Rail information – *www.networkrail.co.uk/apex/959.apex*
South Western Circle, the Historical Society for the LSWR – *www.lswr.org*
Southern Railway Group – *www.srg.org.uk*

Acknowledgements

I would like to acknowledge and thank the many individuals and organisations who have contributed to the production of this book. In particular, Campbell McCutcheon of Amberley Publishing for commissioning the *Through Time* series on London's railway termini. Unless otherwise stated, all new photography is by the author. Additional images have come from a number of sources and I am grateful to the following: The US National Archives & Records Administration (NARA), Campbell McCutcheon (CMcC), Network Rail, Ray Munns Archive Collection (RMAC), Kevin Lane, Barry Lewis, Ben Salter, Timothy Saunders, Owen Dunn, Ilya Khuroshvili, Nick Whiteacre and Ultra7. Final thanks go to my wife, Ute Christopher, who assisted with proof reading. Apologies to anyone left out unknowingly and any such errors brought to my attention will be corrected in subsequent editions. *JC*